HOGARTH TO TURNER

BRITISH PAINTING

THE NATIONAL GALLERY

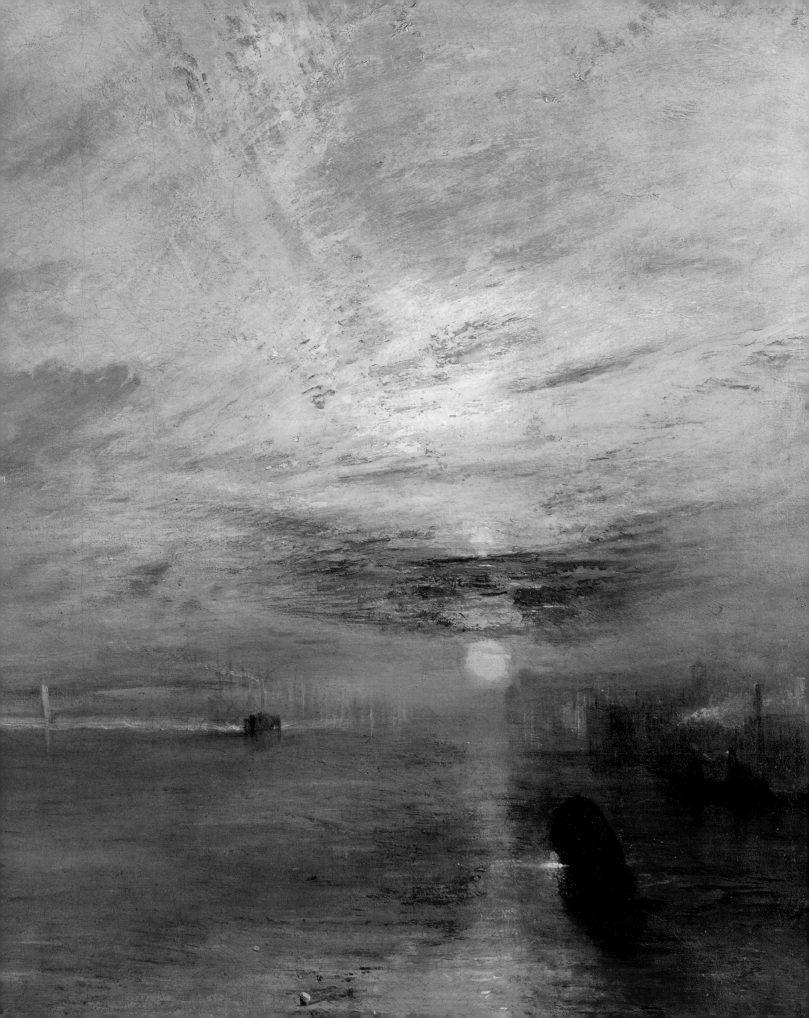

NATIONAL GALLERY COMPANY, LONDON

DISTRIBUTED BY YALE UNIVERSITY PRESS

HOGARTH TO TURNER

BRITISH PAINTING

THE NATIONAL GALLERY

First published in Great Britain in 2010 by
National Gallery Company Limited
St Vincent House
30 Orange Street
London WC2H 7HH
www.nationalgallery.co.uk

ISBN 978 1 85709 487 9
525561

British Library Cataloguing-in-Publication Data
A catalogue record is available from the British Library.
Library of Congress Control Number: 2009937848

Publisher Louise Rice
Project Editor Jan Green
Picture Researcher Suzanne Bosman
Production Jane Hyne and Penny Le Tissier
Designer Joe Ewart for Society

Colour reproduction by D L Interactive UK
Printed in Hong Kong by Printing Express

All measurements give height before width

Written by
Louise Govier

Photographic credits
All works © The National Gallery, London, unless otherwise credited below.
© Tate, London 2009: fig 1; The Royal Collection © 2009 Her Majesty Queen Elizabeth II: fig. 5

Front cover: **Thomas GAINSBOROUGH** (1727–1788), *Mrs Siddons*, 1631–2 (detail, plate 17)
Frontispiece: **J.M.W. TURNER** (1775–1851), *The Fighting Temeraire*, 1839 (detail, plate 34)
Page 6: **John CONSTABLE** (1776–1837), *The Cornfield*, 1826 (detail, plate 28)
Page 52: **Thomas GAINSBOROUGH** (1727–1788), *The Painter's Daughters with a Cat*, **probably about 1760–1** (detail, plate 16)

CONTENTS

Introduction

British painting has been part of the National Gallery ever since its foundation in 1824. Most of the influential connoisseurs who campaigned for the creation of a national public art collection owned British art themselves: Sir George Beaumont (1753–1827), for example, was one of John Constable's great patrons. Beaumont offered to donate his collection if the British government would purchase John Julius Angerstein's paintings, making the bargain clear: 'Buy Angerstein's pictures, and I will give you mine!' Angerstein's collection contained nine British works, including Hogarth's biting satirical series *Marriage A-la-Mode*.

Today, the British collection has a particular focus on outstanding portraiture and landscape. In the nineteenth and early twentieth centuries, however, it covered a wider range of genres, including religious and literary subjects by the Pre-Raphaelite Brotherhood and humorous, moralising descriptions of everyday life. Most of these works, such as Dante Gabriel Rossetti's *Annunciation* (1849–50), Sir David Wilkie's scene of a drunken *Village Holiday* (1809–11) and William Powell Frith's *Derby Day* (1856–8), are now in Tate Britain, which grew out of the ever-expanding National Gallery.

Although many of the Gallery's nineteenth-century directors focused on acquiring foreign art for the collection, substantial bequests and purchases of British painting were still made. When Robert Vernon left a large collection of British art to the nation in 1845, there was not enough room to show it in Trafalgar Square, as the Gallery's premises there were far smaller than they are today. It was therefore displayed separately, initially at Vernon's private house and then at Marlborough House. The number of native works grew even more significantly when J.M.W. Turner bequeathed nearly 300 paintings and more than 19,000 drawings and watercolours to the nation. A selection of these was exhibited together with Vernon's collection at the South Kensington Museum, now the Victoria and Albert Museum.

The National Gallery's building in Trafalgar Square was expanded in 1876, creating enough space to reunite the British paintings with the rest of the collection. However, the precedent had been set for British pictures to be exhibited on a separate site. Some critics also felt that a substantial independent display devoted to the national school was an important way of honouring the achievements of recent British artists. In 1890, the wealthy industrialist Sir Henry Tate offered to fund the construction of a new gallery that would concentrate on British works of art, adding his own significant collection, which included Sir John Everett Millais's *Ophelia* (1851–2) and *The Lady of*

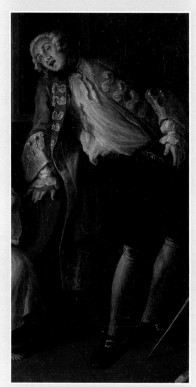

Shalott by John William Waterhouse (fig. 1). This finally opened in 1897 on the banks of the River Thames, a mile away from Trafalgar Square. Its official name was the National Gallery of British Art, but it soon became known as the Tate Gallery, although it did not become an independent organisation until 1954.

A considerable number of British paintings were transferred to the spacious new premises, leaving a smaller collection of key masterpieces in Trafalgar Square. These were never meant to be representative of the entire development of British art; that story is told more comprehensively at Tate Britain. Instead, the National Gallery's select group shows how British painting connected with and contributed to what was happening in the rest of Europe. It reveals a succession of artists striving to improve standards of training, theory and practice, who balanced the demands of their local market with an awareness of developments on the continent. They did not want to lose out, as their professional predecessors had, to more skilful foreign artists, who arrived with techniques honed during years of formal training and were promptly offered lucrative commissions by British aristocrats, who believed that all the best painters came from abroad.

Aspiring artists such as William Hogarth were keen to supply these patrons with home-grown art, but found that it was not always easy to overcome their prejudices. In 1735, when Hogarth heard that the governors of St Bartholomew's Hospital were planning to commission the Venetian painter Jacopo Amiconi (1682–1752) to decorate the grand staircase of their new building, he offered to do the work for free. However, the resulting paintings (still in place) lacked compositional coherence, and we can see from *Marriage A-la-Mode: 5, The Bagnio* (fig. 2) that Hogarth struggled to paint believable human anatomy. Life classes where young artists could study the human form with more experienced practitioners were still rare in Britain.

Initially an engraver, Hogarth basically taught himself how to paint. Portraits such as *The Graham Children* (fig. 3 and no. 3) show his ability to create penetrating, multi-layered representations of his sitters. However, not all of Hogarth's potential clients could accept his refusal to flatter or to gloss over life's sometimes painful complexities, and his portraiture practice dwindled. Seeking new business opportunities, Hogarth developed an original type of art, the 'modern moral subject'. *Marriage A-la Mode* (a series of six paintings, of which the first and last are featured in this book: nos 1 and 2) is a superlative example. The series develops as a comic yet also deeply sad soap opera, with Hogarth carefully mixing caricature and pathos to keep his audience smiling as they sigh at the sorry outcome of this tale. Such work made Hogarth's name, although to his annoyance, his artistic peers refused to take it seriously as a 'high' art form.

Hogarth was shrewd in assuming that his audience was deeply interested in itself, even if self-reform was not always uppermost in the minds of those who bought the high-quality prints he issued after his original paintings.

Mostly, British patrons wanted more idealised representations of themselves and their status. Ownership of land was a hugely important part of their identity in many cases, and British artists developed ways to use that in portraiture, inventing what became known as the 'outdoor conversation piece'. Thomas Gainsborough's *Mr and Mrs Andrews* (no. 7) and George Stubbs's *The Milbanke and Melbourne Families* (no. 9) are superb examples of this particularly British form of portraiture.

Both these paintings were commissioned to commemorate marriages, yet they seem unconcerned with love or affection. This was in line with the social and artistic conventions of the day. But Joseph Wright's portrait of *Mr and Mrs Thomas Coltman* (no. 10) is an exception, perhaps because the couple were close friends of the artist. Based in Derby for much of his career, Wright produced some ambitious, highly original work. *An Experiment on a Bird in the Air Pump* (fig. 4 and no. 11) presents the drama of a scientific demonstration of the fact that a bird, like a human being, needs to breathe air in order to survive. Wright's painting asks major questions about religion, science and morality, and both reflects and contributes to the spirit of enquiry that seemed to pervade this 'age of enlightenment'.

George Stubbs was also interested in dramatic, sublime subjects, but focused instead on the British passion for animal paintings. He met the growing interest in thoroughbred horse racing with his own detailed understanding of equine anatomy, gained through years spent dissecting horse carcasses. Patrons were prepared to pay considerable amounts for accurate portraits of their favourite stallions, including *Whistlejacket* (no. 12). However, like Hogarth before him, Stubbs also found that his work was not particularly valued by the growing art establishment in London, which did not consider animals to be sufficiently serious or difficult subjects. It failed to recognise that Stubbs aimed to challenge both mind and soul with his representations of the power of nature. The establishment fought hard to maintain a set of standards it had only just put in place. Throughout the eighteenth century, there had been a growing campaign among British artists for a professional organisation, along the lines of the academies of art that had been operating in Italy and France for more than a century. These provided formal, centralised training in subjects such as anatomy, history and large-scale composition, and offered regular, high-profile exhibition opportunities. They also conferred a professional status on artists who were sensitive to the prevailing view that they were still little more than craftsmen.

The campaign finally met with success under the patronage of George III, who supported the founding of the Royal Academy of Arts in 1768, with Joshua Reynolds (later knighted) as its first president, and Johann Zoffany (see no. 19) as one of the founder members. It is clear from his *Discourses* – his annual speeches to the Academy and its students – that Reynolds felt that study programmes along the lines of continental academies would greatly improve the ambition and technical skill of British painting. He also hoped to persuade

opposite:
Fig. 4
Joseph WRIGHT 'of Derby' (1734–1797)
An Experiment on a Bird in the Air Pump,
1768 (detail, plate 11)

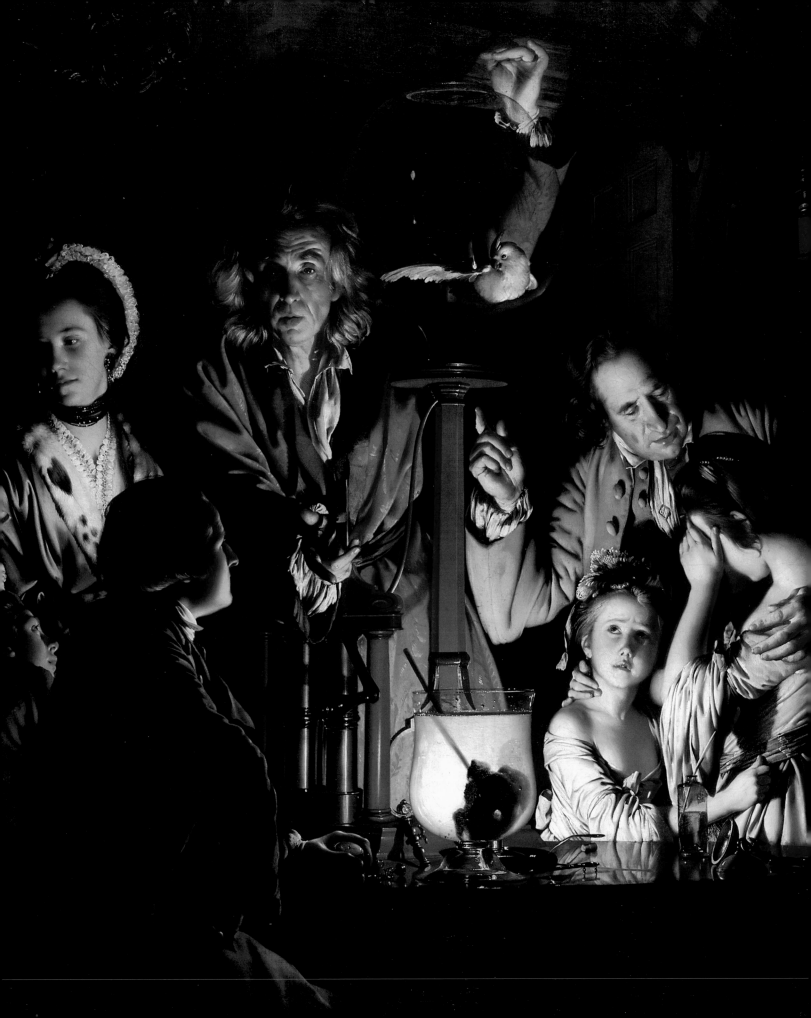

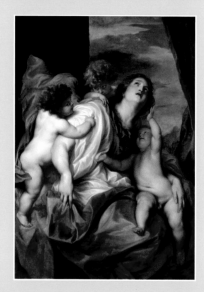

more British patrons to commission historical, biblical or literary subjects, which according to the French 'hierarchy of genres' were the most difficult but also the most worthy subjects to paint.

However, the British market remained for the most part stubbornly attached to its beloved portraits, landscapes and scenes from everyday life. Reynolds was frustrated, not only by the lack of patrons for historical works but also by his own limited skills. He had not had the benefit of the training now on offer to new students, so his few historical canvases seem oddly composed, and feature badly drawn figures. When his painting of *The Death of Dido* (fig. 5) was exhibited at the Royal Academy's annual exhibition in 1781, it was ridiculed by the press. Mrs Thrale, patron of the arts and friend of Dr Johnson and other literary figures, offered a particularly stinging criticism of Reynolds's lofty ambitions, which were for her unmatched by his skills: 'A rage for sublimity ill-understood; to seek still for the great by forsaking the good.'

Both market forces and his own talents therefore conspired to keep Reynolds working mostly within portraiture. Wherever possible, he sought to elevate this supposedly lesser genre with references to great art works from the classical and European traditions. His portraits of *Captain Robert Orme* (no. 13), *Colonel Tarleton* (no. 14) and *Lady Cockburn and her Three Eldest Sons* (no. 15) all make visual connections to history paintings or classical sculpture. Lady Cockburn's pose is based on a representation of *Charity* by Sir Anthony van Dyck (fig. 6), while that of her eldest son derives from the figure of Cupid in Velázquez's *Rokeby Venus* (1647–51), also in the National Gallery.

But not all clients wanted such complex, occasionally convoluted work, however grand the result; and so Thomas Gainsborough remained a potent rival to Reynolds. His style developed from the tightly controlled brushstrokes that delineated Mr and Mrs Andrews in the middle of the century (no. 7). In later decades, Gainsborough constructed his portraits from expressive, fluid touches of paint that seem inspired by the Flemish painter Peter Paul Rubens. From his intimate rendering of his two children, *The Painter's Daughters with a Cat* (no. 16), to his sparkling society portraits of *Mrs Siddons* (no. 17) and *Mr and Mrs William Hallett ('The Morning Walk')* (no. 18), Gainsborough creates extraordinary, evocative paint surfaces. Even Reynolds was forced grudgingly to admit that 'all those odd scratches and marks' did in fact 'by a kind of magic, at a certain distance … seem to drop into their proper places'.

Gainsborough's technique was developed in subsequent generations, most brilliantly perhaps by Sir Thomas Lawrence (see no. 20, *Queen Charlotte*) and Sir Henry Raeburn (see no. 21, *'The Archers'*). Raeburn's careful consideration for shape and line would also be echoed by a later portrait artist with a deft and dazzling technique, John Singer Sargent (see no. 22, *Lord Ribblesdale*). Although Sargent was an American citizen, he settled in London in 1885 and was based there until his death forty years later, and so is included in the National Gallery's British School.

Fig. 5
Sir Joshua REYNOLDS (1723–1792)
The Death of Dido, 1781
Oil on canvas, 142 × 251 cm
The Royal Collection

Fig. 6
Sir Anthony van DYCK (1599–1641)
Charity, about 1627–8
Oil on oak, 148.2 × 107.5 cm
London, National Gallery

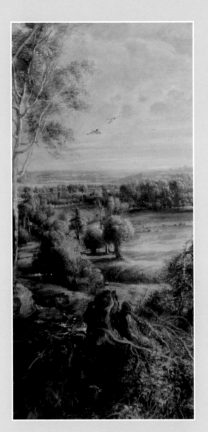

Perhaps ironically, in view of Reynolds's fervent belief in the hierarchy of genres, it was British landscape painters who would attract international praise with ambitious, ground-breaking work. Native artists had already developed different approaches inspired by earlier European traditions which had proved successful in the past. The 'picturesque' landscape grew out of the grey skies and dense vegetation of seventeenth-century Dutch scenes: Gainsborough's *Cornard Wood, near Sudbury, Suffolk* (no. 5) is a prime example. The idealised sun-soaked landscapes of both the seventeenth-century French master Claude Lorrain and his Dutch emulator Aelbert Cuyp were visual resources for Richard Wilson (see no. 25, *Holt Bridge on the River Dee*). But it was Constable and Turner who would develop landscape painting along radically new lines, claiming a new importance for the genre that would have long-lasting implications.

Turner and Constable both spent hours sketching from nature, always reworking their outdoor observations into more finished paintings in the studio. The National Gallery's collection contains a number of lively, evocative landscape sketches by a range of other British artists, its holdings in this area strengthened substantially by the long-term loan of the Gere Collection of landscape oil sketches (see for example Frederic, Lord Leighton's *The Villa Malta, Rome*, no. 24). In 1993, the Gallery was also able to acquire Thomas Jones's absorbing study of *A Wall in Naples* (no. 23).

Constable treated outdoor work as simply the first stage in a complex process of creation. He constructed his landscapes with just as much thought and intellectual intervention as a history painter, and claimed a similar importance for them. It was a bold move for him to present landscapes such as *Stratford Mill* (no. 26) and *The Hay Wain* (no. 27) as major, large-scale, universal works that were part of a series – he called them his 'six-footers' – and to use them as the basis for advancing grand theories about 'the chiaroscuro of nature'. Constable was also responding openly to great European art from the past. He had studied Rubens's *View of Het Steen in the Early Morning* (fig. 7) when it hung in the breakfast room of his patron Sir George Beaumont, and *The Hay Wain* pays clear homage to the earlier master.

Constable's textured painting technique, where dashes of colour were scraped on with a palette knife, or light applied in tiny flecks or dragged strokes, was also a challenge for his viewers. His depiction of the cenotaph to the memory of Sir Joshua Reynolds in the grounds of Beaumont's country home (no. 30) was condemned by *Blackwood's Magazine* as 'scratchy and uncomfortable in execution' and 'flickering throughout with impertinent lights, and dots of all colours, utterly ruinous to the sentiment'.

Turner pushed the boundaries of the genre even further, using his land- and seascapes to represent subjects from classical history and literature, insisting that light and colour, and textures which ranged from thin washes to thick impasto, could express complex ideas and emotions. A sunset represented the

Fig. 7
Peter Paul RUBENS (1577–1640)
An Autumn Landscape with a View of Het Steen in the Early Morning, probably 1636 (detail)
Oil on oak, 131.2 x 229.2 cm
London, National Gallery

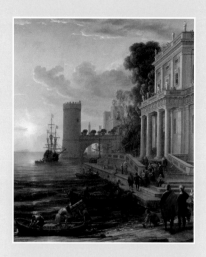

dying days of an old warship, towed away against a luminous backdrop that suggested a blaze of former glory (no. 34, *The Fighting Temeraire*). Turner also drew inspiration from the masterpieces of previous centuries: he worshipped Claude, and included a clause in his bequest which directed that some of his paintings should always be displayed next to works by the great French landscape artist. Turner's *Dido building Carthage* (no. 32) still usually hangs next to Claude's *Seaport with the Embarkation of the Queen of Sheba* (fig. 8), so that visitors to the Gallery can see how his work relates to art from the past. At the same time, Turner's landscapes could be conspicuously modern, treating contemporary subjects with daring compositions and intriguing ambiguity (see no. 35, *Rain, Steam and Speed – the Great Western Railway*).

Even though such developments often received a mixed press at home, they had a considerable impact in the rest of Europe, particularly in France. Constable's *Hay Wain* was lauded in Paris when it was shown there in 1824. His technique inspired Eugène Delacroix to add touches of pure colour to his own work, a move that would be noticed and explored further by the generation which produced the Impressionists. Turner's work seems even more clearly to foreshadow the radical departure that late nineteenth-century French artists would take in terms of their subject matter, composition and technique. *Margate (?), from the Sea* (no. 36) had to wait for half a century after the Turner Bequest of 1856 before it was displayed, its hazy surface interpreted by successive curators as a sign that it was unfinished. Only after the example of the Impressionists was Turner's work reconsidered as perhaps a deliberately misty, shifting recollection of the sea.

By the middle of the nineteenth century, British artists no longer seemed to be the under-trained, under-exposed 'poor relations' of their continental cousins. Today, as visitors to the National Gallery move from the British rooms into the French Impressionist collections, it is clear just how much of a contribution British painters made to European artistic traditions. Moreover, their works have also stood the test of time, one of the early criteria for National Gallery directors as they decided which British works to collect. The paintings by Hogarth, Gainsborough, Constable, Turner and their colleagues featured in this book are now some of the best-loved works in the National Gallery.

Louise Govier

Fig. 8
CLAUDE (1604/5–1640)
Seaport with the Embarkation of the Queen of Sheba, 1648 (detail)
Oil on canvas, 149.1 x 196.7 cm
London, National Gallery

opposite:
Fig. 9
J.M.W. TURNER (1775–1851)
Dido building Carthage, or The Rise of the Carthaginian Empire, 1817
(detail, plate 32)

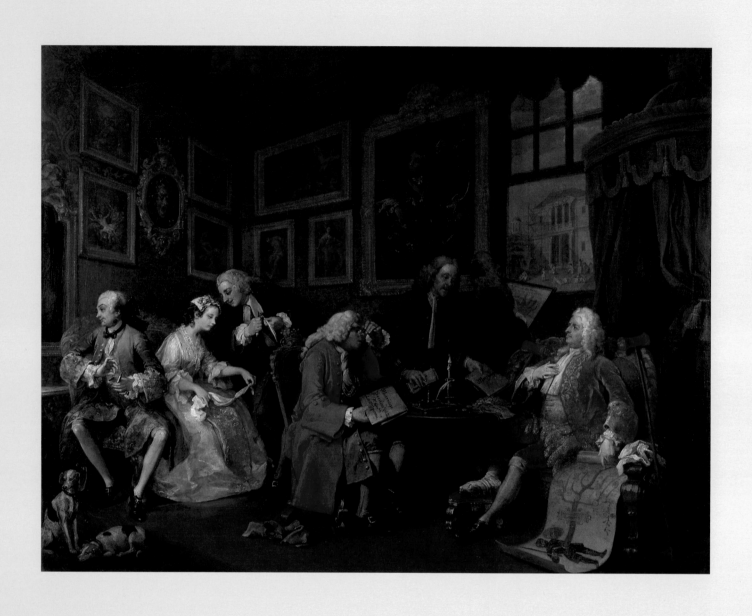

1 William HOGARTH (1697–1764) *Marriage A-la-Mode:*
I, The Marriage Settlement, about 1743

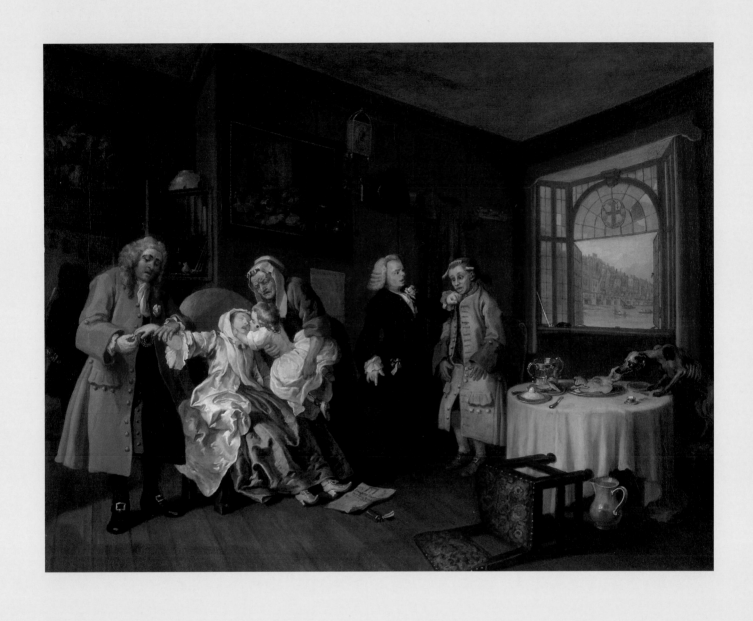

2 William HOGARTH (1697–1764) *Marriage A-la-Mode:*
6, The Lady's Death, about 1743

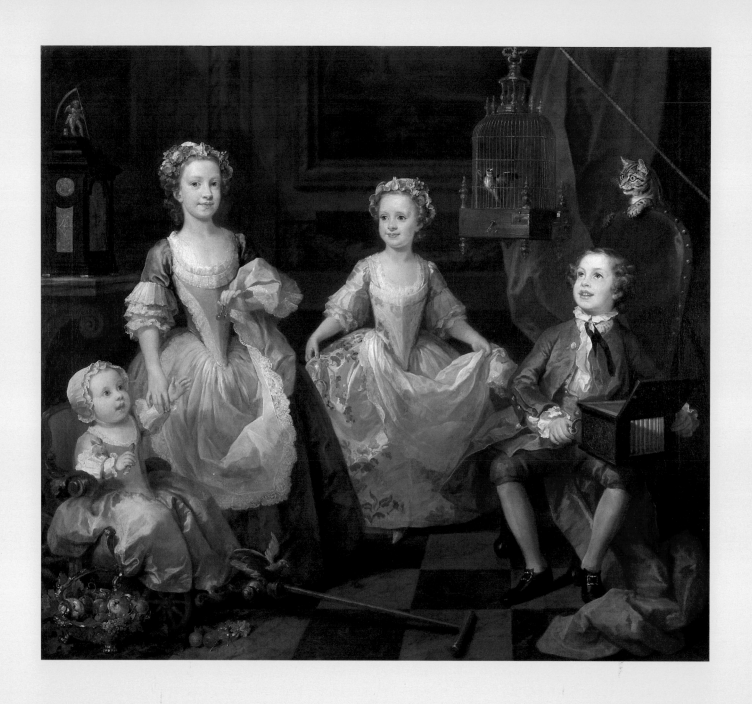

3 William HOGARTH (1697–1764) *The Graham Children*, 1742

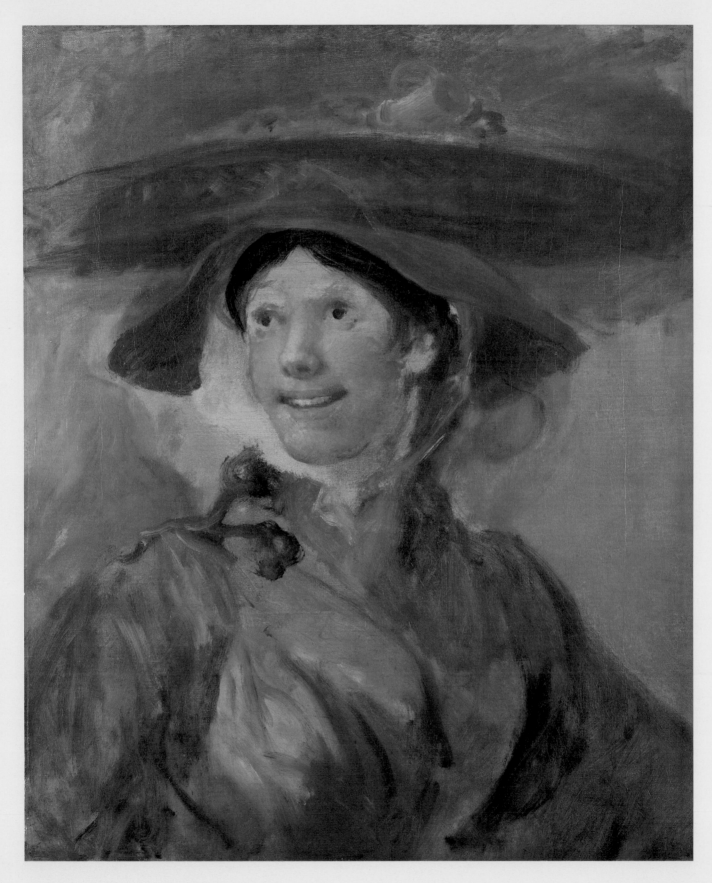

4 William HOGARTH (1697–1764) *The Shrimp Girl*, about 1740

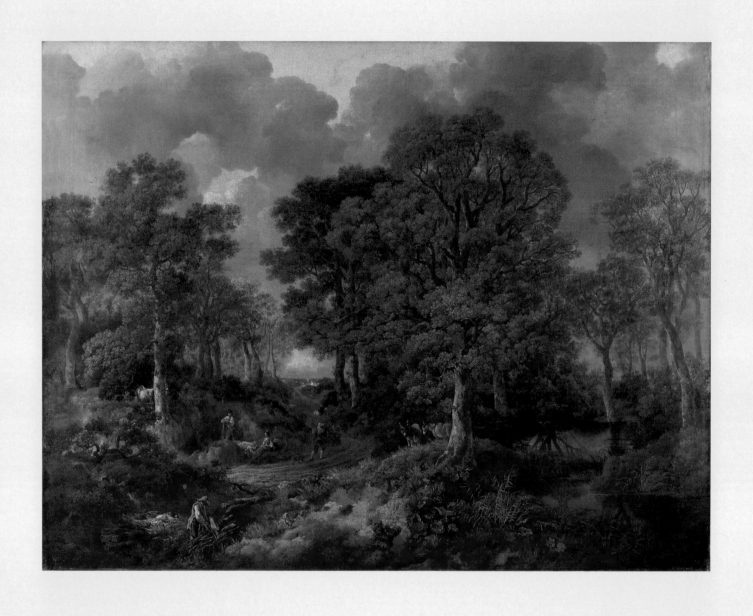

5 Thomas GAINSBOROUGH (1727–1788) *Cornard Wood, near Sudbury, Suffolk*, 1748

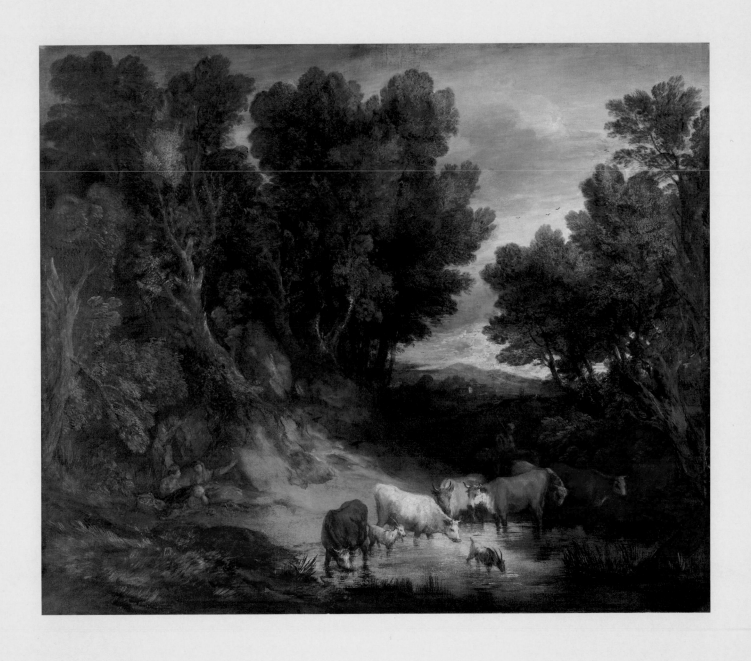

6 Thomas GAINSBOROUGH (1727–1788) *The Watering Place*, before 1777

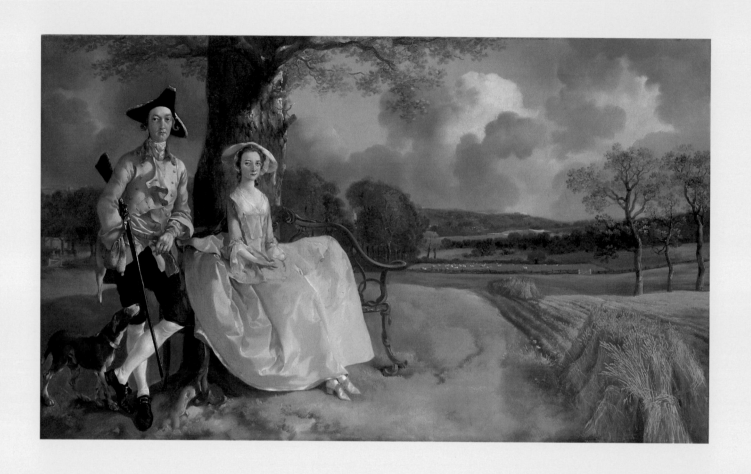

7 Thomas GAINSBOROUGH (1727–1788) *Mr and Mrs Andrews*, about 1750

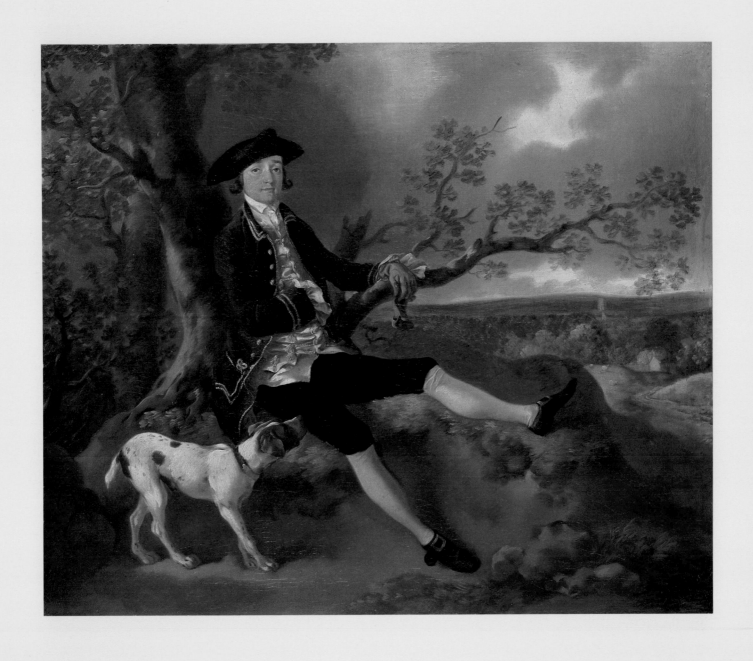

8 Thomas GAINSBOROUGH (1727–1788) *John Plampin*, probably about 1752

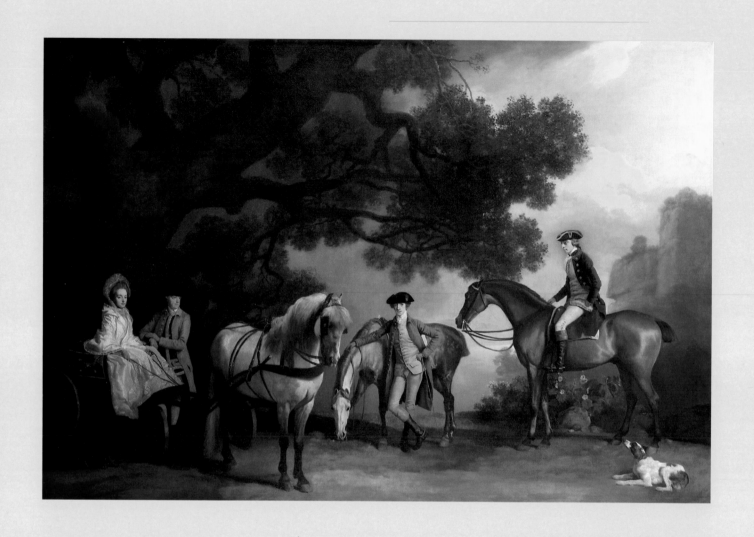

9 George STUBBS (1724–1806) *The Milbanke and Melbourne Families,* about 1769

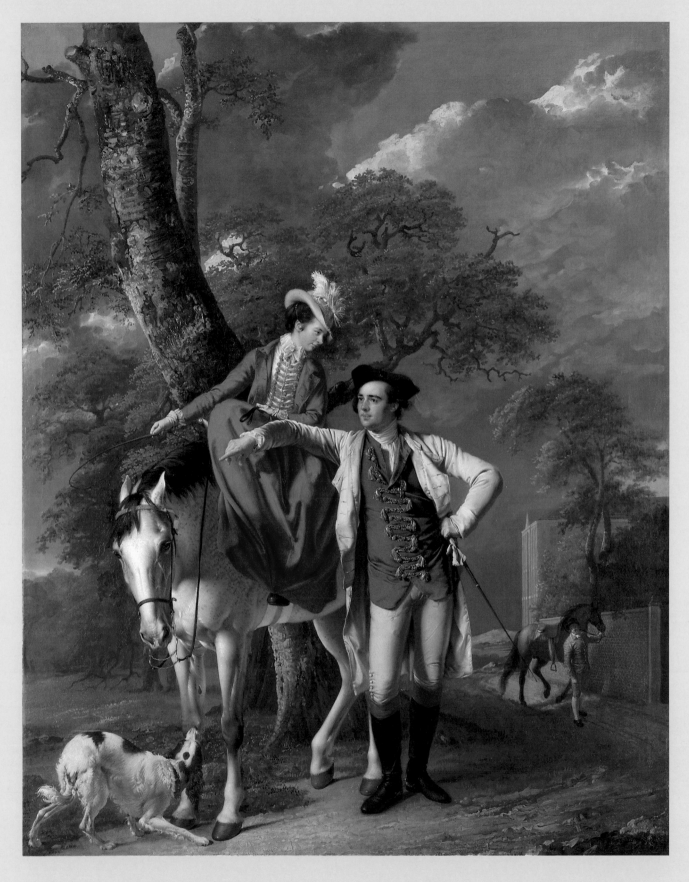

10 Joseph WRIGHT 'of Derby' (1734–1797) *Mr and Mrs Thomas Coltman*, about 1770–2

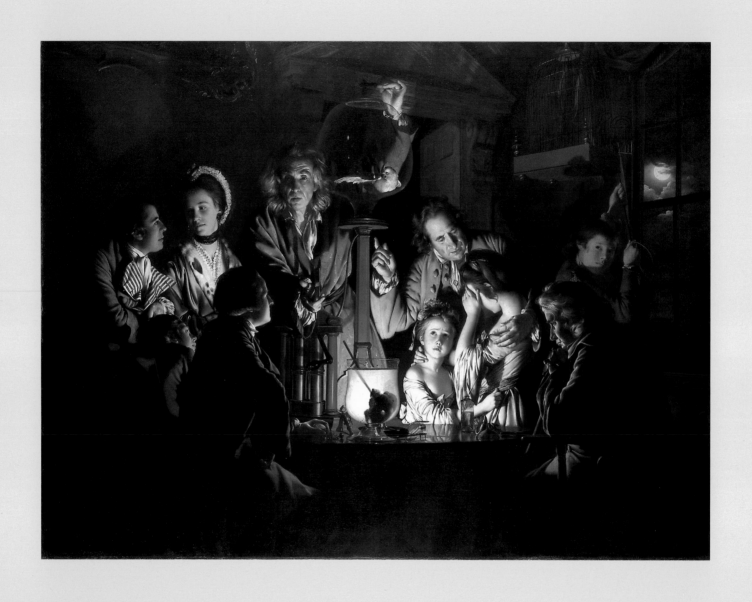

11 Joseph WRIGHT 'of Derby' (1734–1797) *An Experiment on a Bird in the Air Pump*, 1768

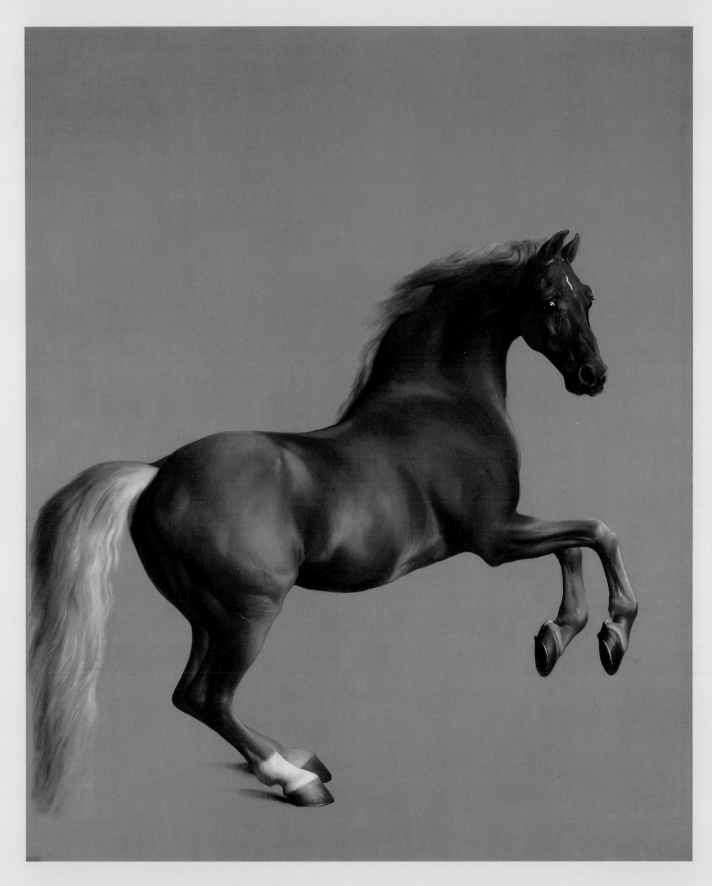

12 George STUBBS (1724–1806) *Whistlejacket*, about 1762

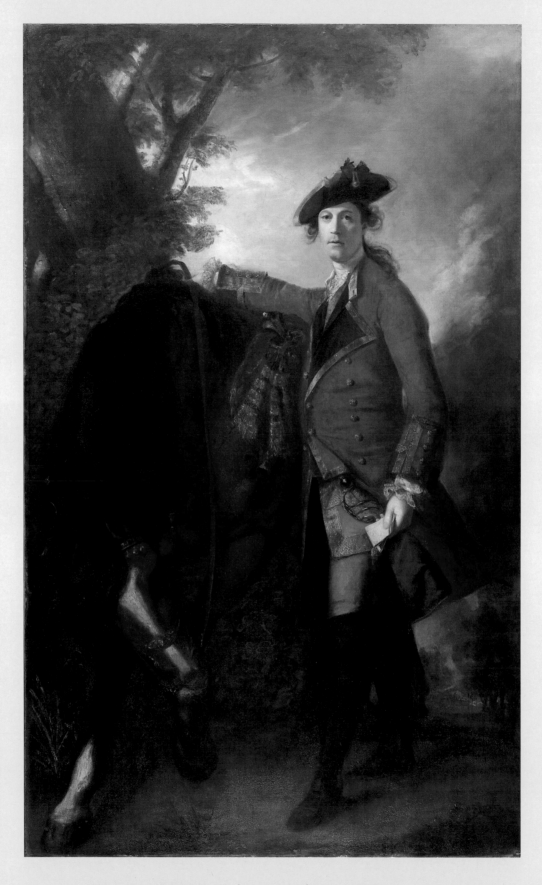

13 Sir Joshua REYNOLDS (1723–1792) *Captain Robert Orme*, 1756

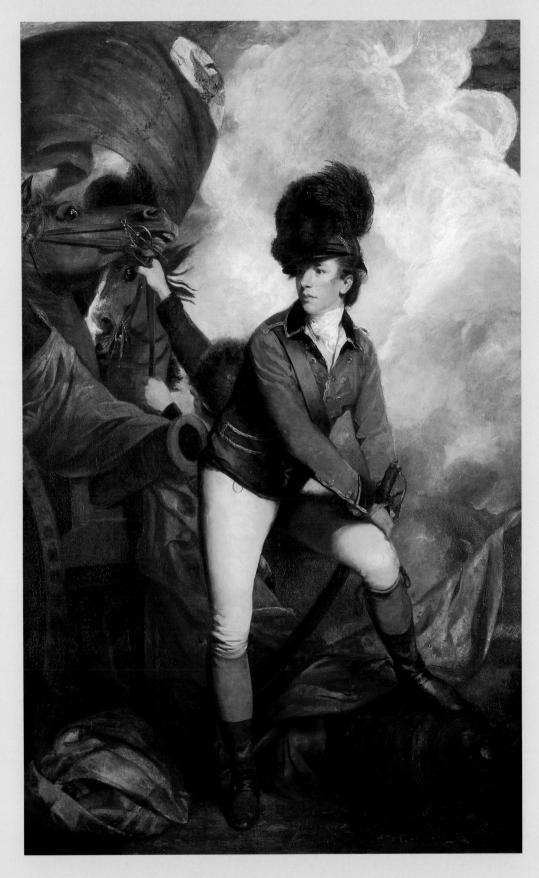

14 Sir Joshua REYNOLDS (1723–1792) *Colonel Tarleton*, 1782

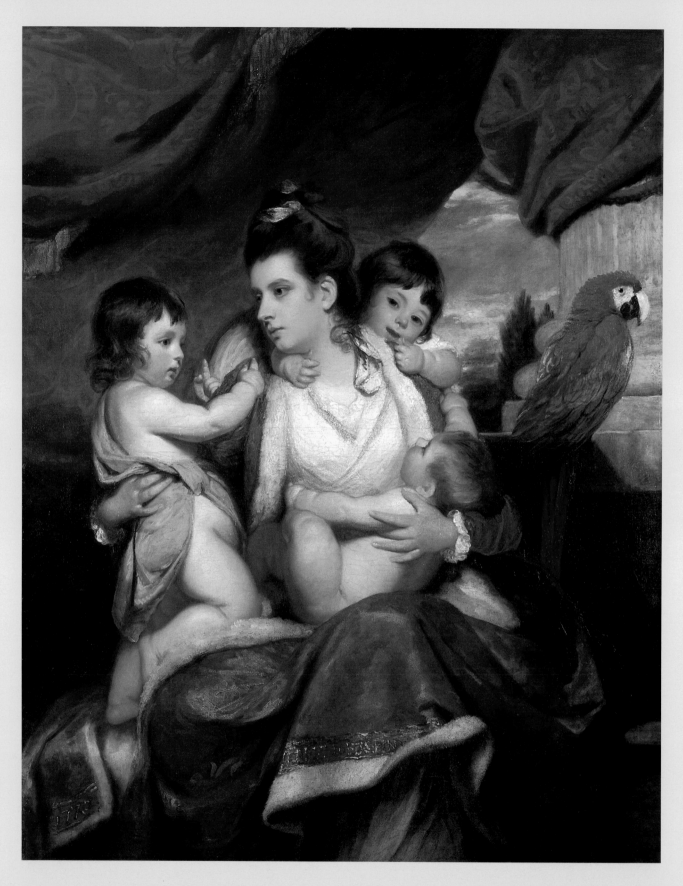

15 Sir Joshua REYNOLDS (1723–1792) *Lady Cockburn and her Three Eldest Sons*, 1773

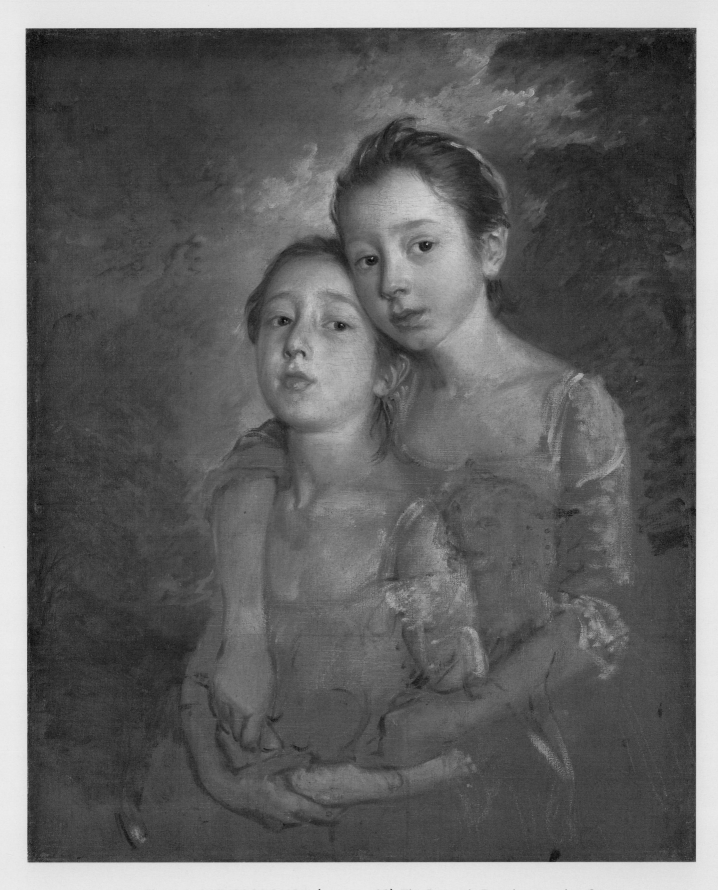

16 Thomas GAINSBOROUGH (1727–1788) *The Painter's Daughters with a Cat,*
probably about 1760–1

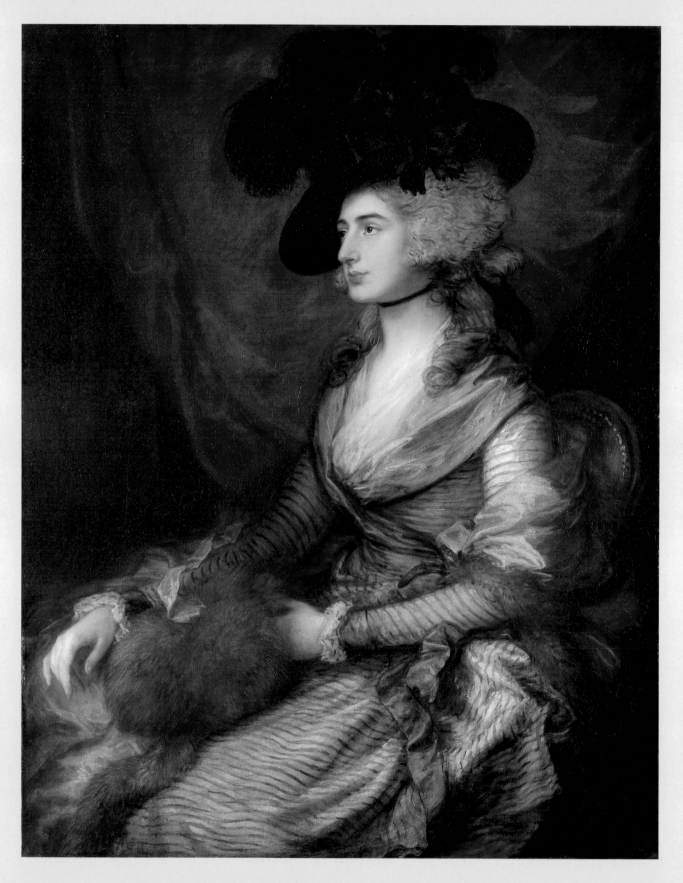

17 Thomas GAINSBOROUGH (1727–1788) *Mrs Siddons*, 1785

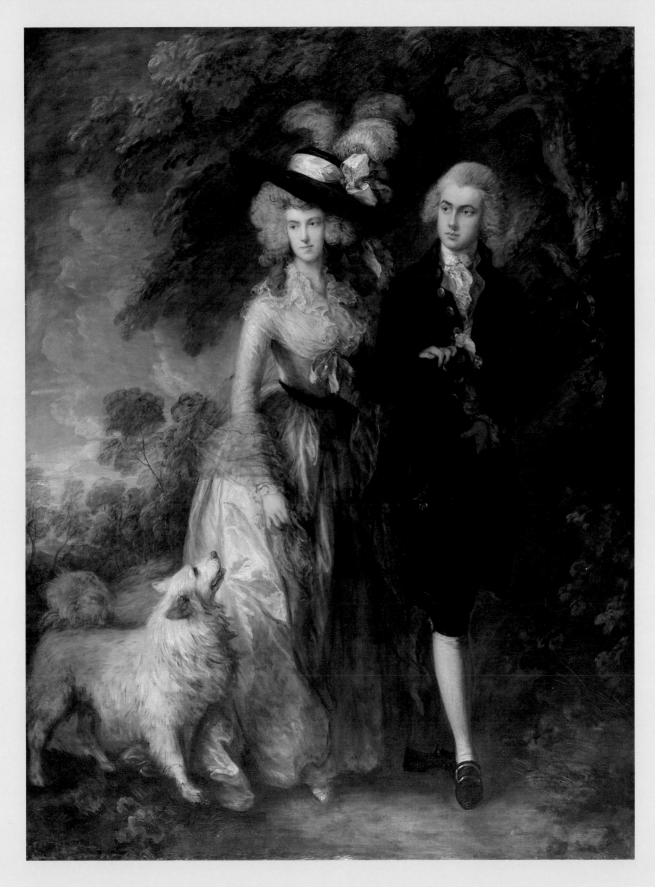

18 Thomas GAINSBOROUGH (1727–1788) *Mr and Mrs William Hallett*
('The Morning Walk'), 1785

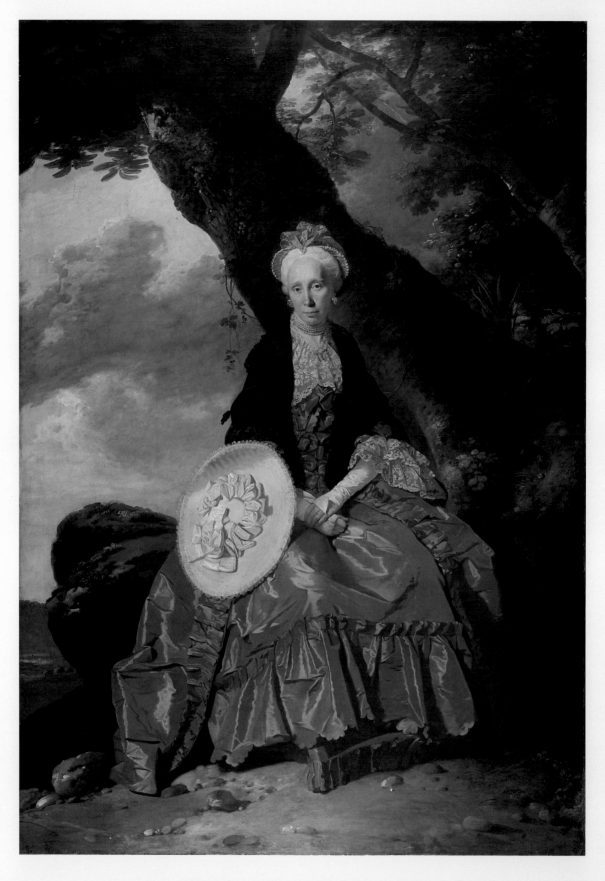

19 Johann ZOFFANY (1733?–1810) *Mrs Oswald*, about 1763–4

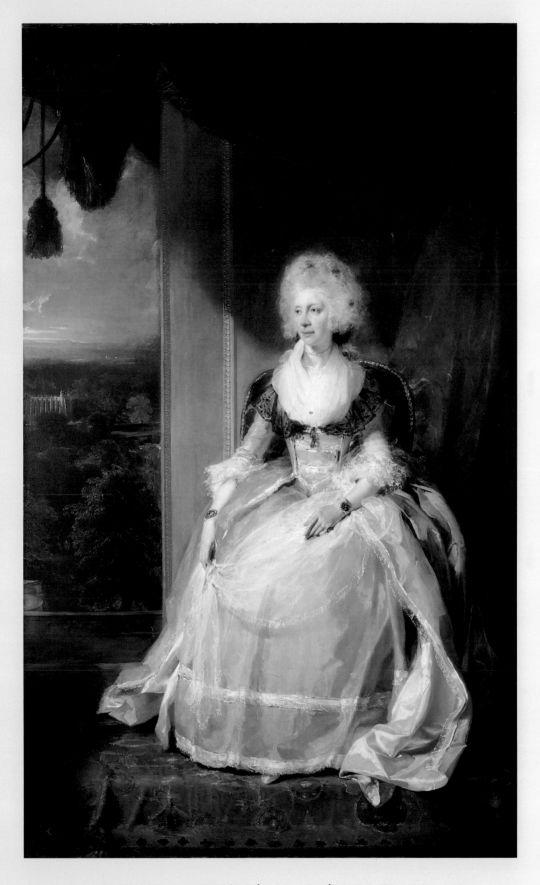

20 Sir Thomas LAWRENCE (1769–1830) *Queen Charlotte,* 1789

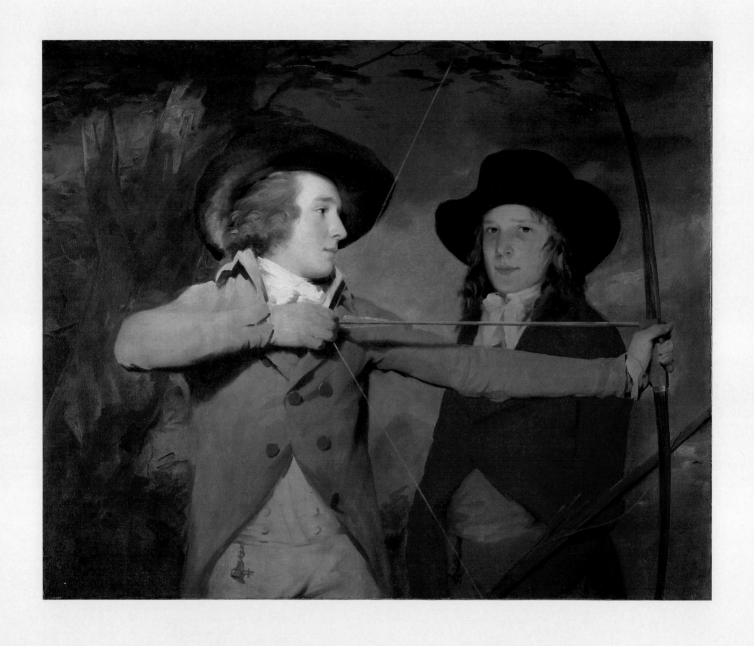

21 Sir Henry RAEBURN (1756–1823) *'The Archers'*, about 1789–90

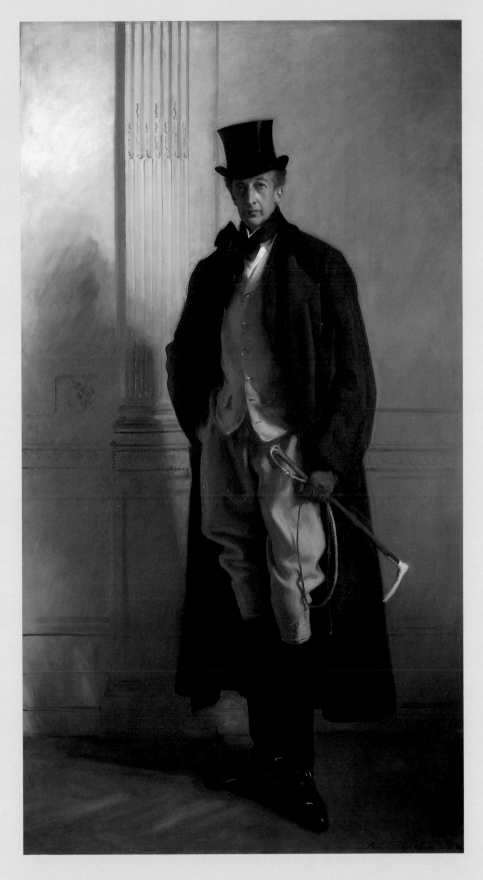

22 John Singer SARGENT (1856–1925) *Lord Ribblesdale*, 1902

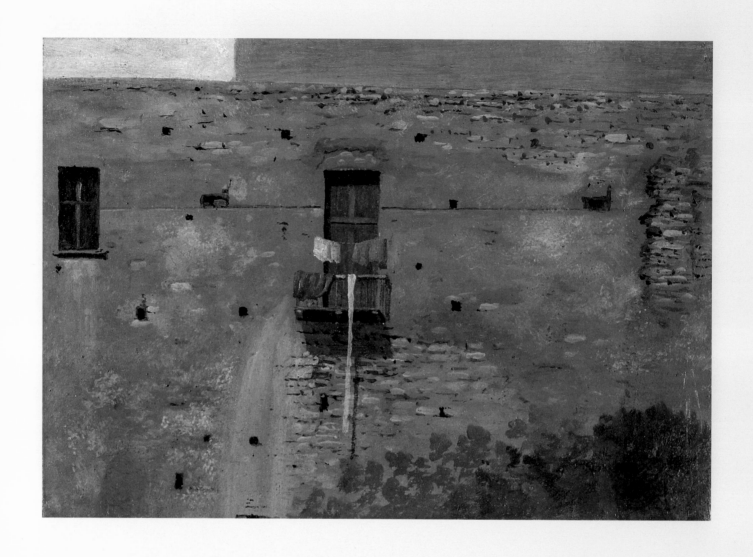

23 Thomas JONES (1742–1803) *A Wall in Naples,* about 1782

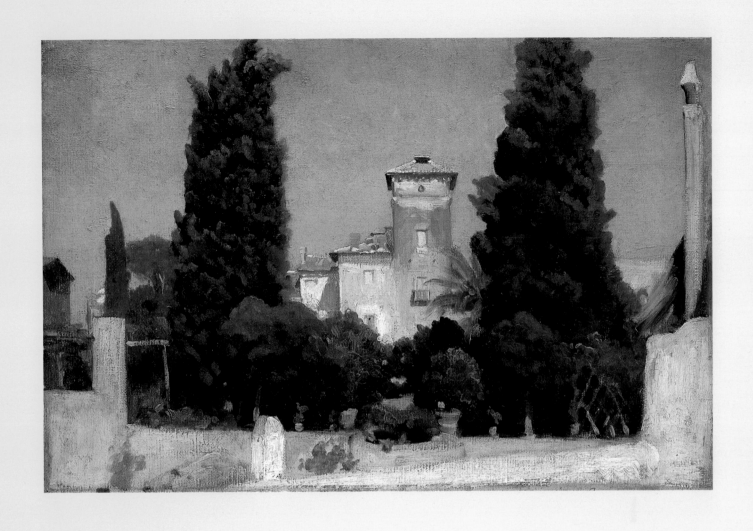

24　Frederic, Lord LEIGHTON (1830–1896) *The Villa Malta, Rome*, 1860s

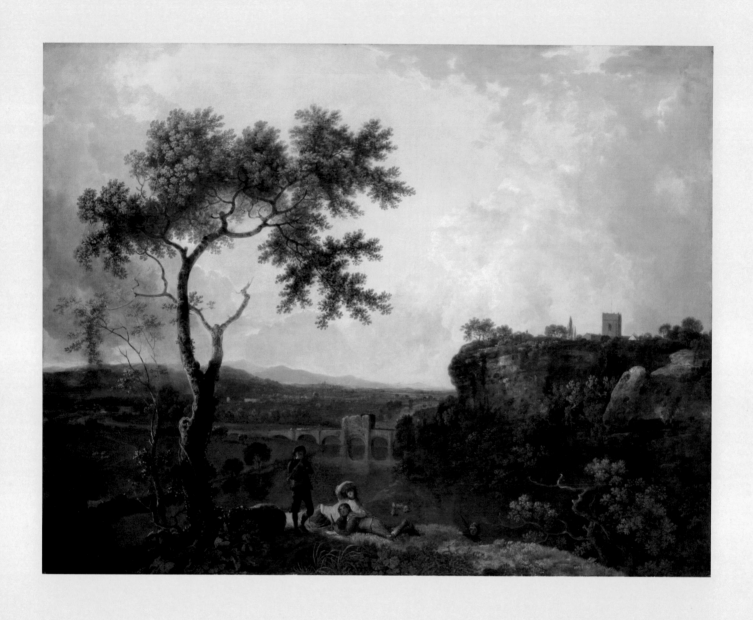

25 Richard WILSON (1713/14–1782) *Holt Bridge on the River Dee*, before 1762

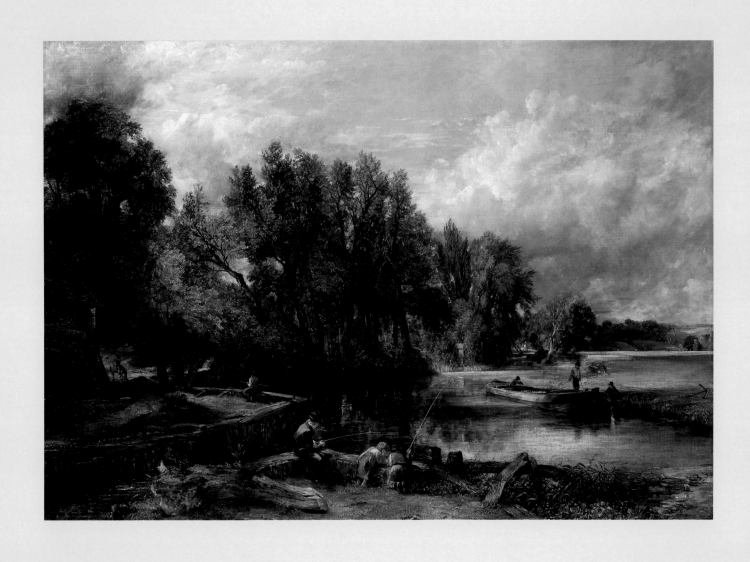

26 John CONSTABLE (1776–1837) *Stratford Mill*, 1820

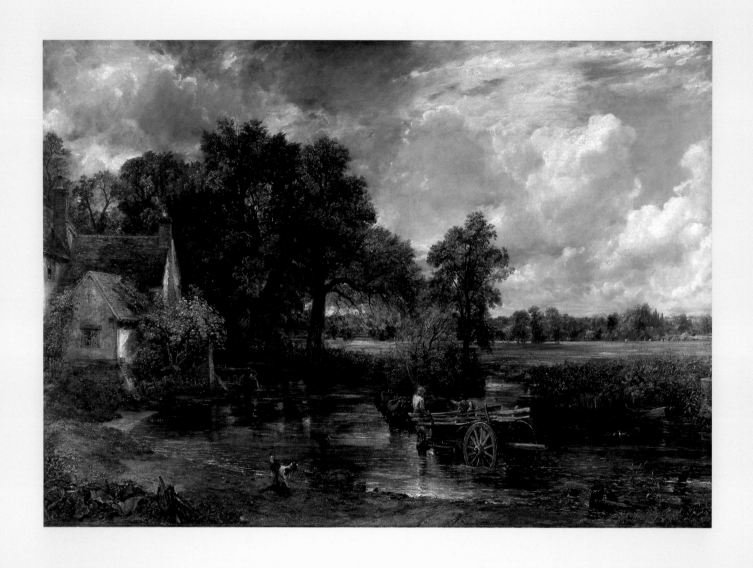

27 John CONSTABLE (1776–1837) *The Hay Wain*, 1821

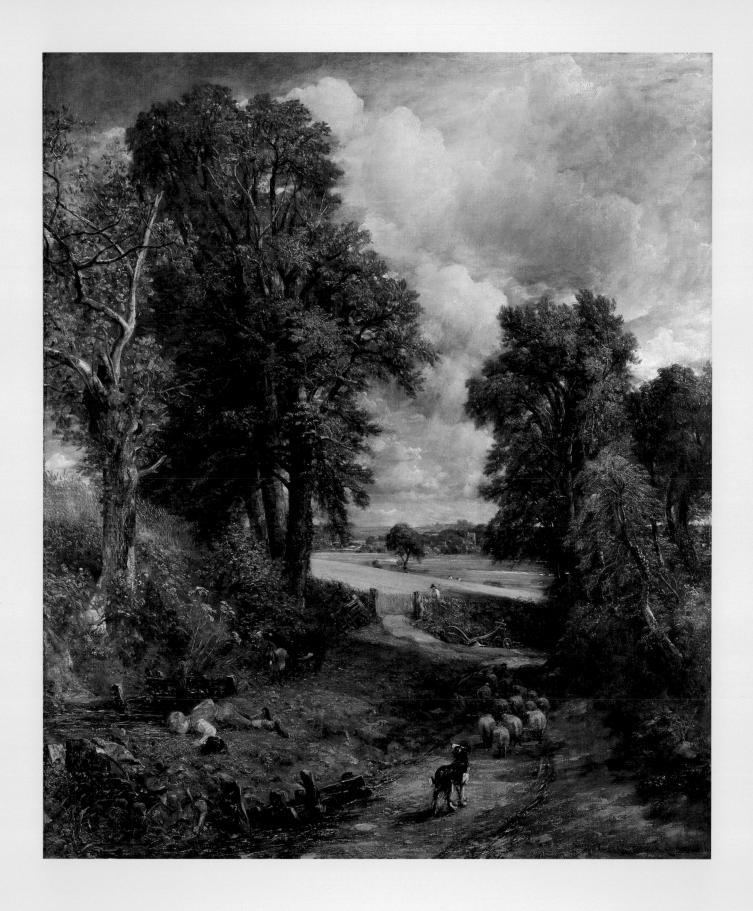

28 John CONSTABLE (1776–1837) *The Cornfield*, 1826

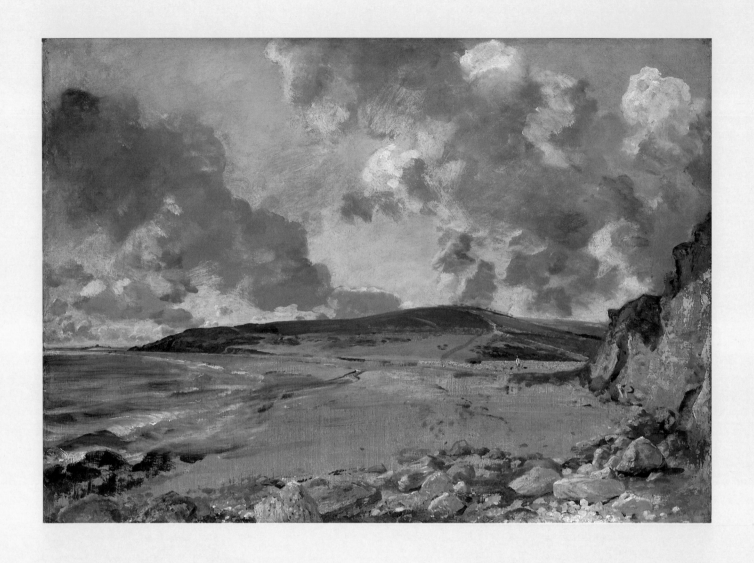

29 John CONSTABLE (1776–1837) *Weymouth Bay: Bowleaze Cove and Jordon Hill*, 1816–17

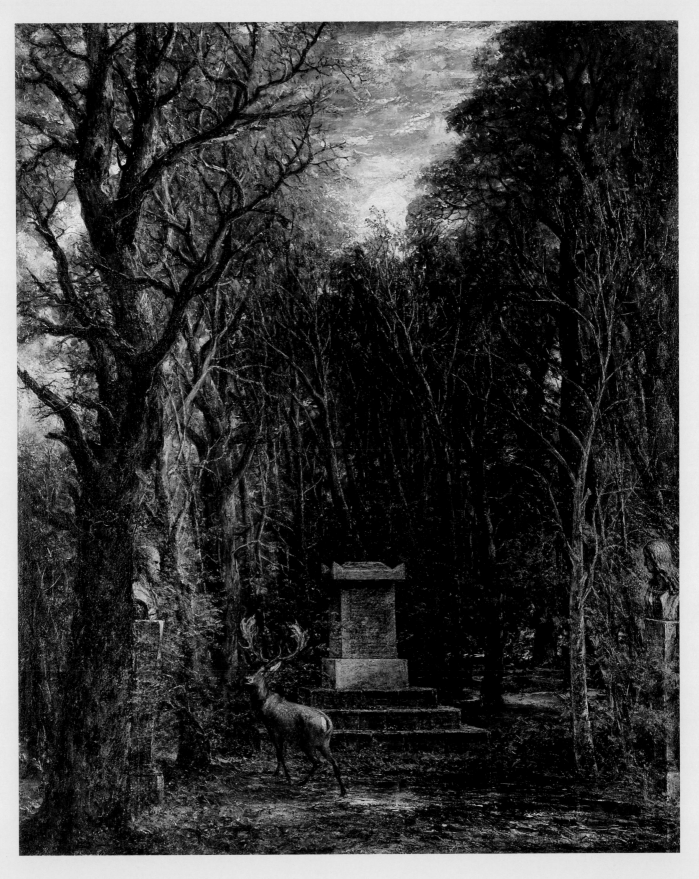

30 John CONSTABLE (1776–1837) *Cenotaph to the Memory of Sir Joshua Reynolds, 1833–6*

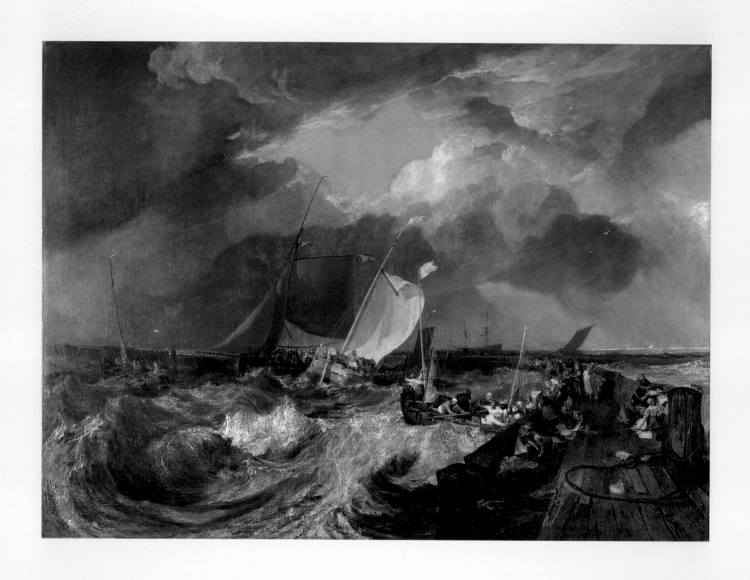

31 Joseph Mallord William TURNER (1775–1851) *Calais Pier*, 1803

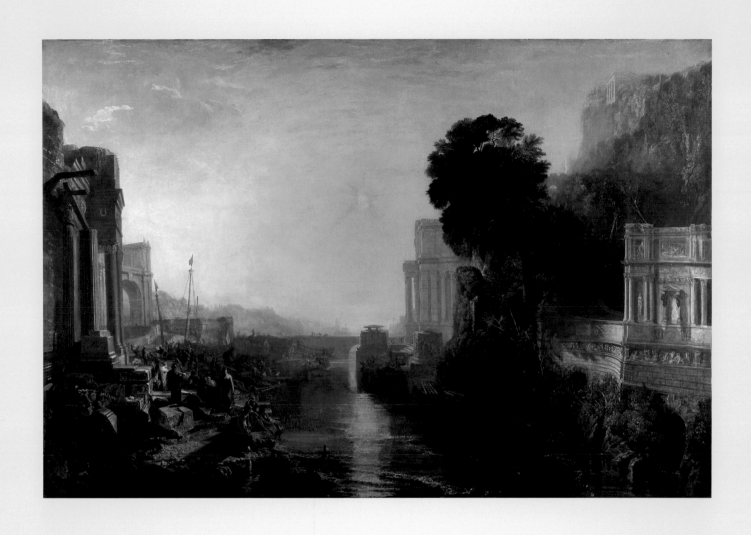

32 Joseph Mallord William TURNER (1775–1851) *Dido building Carthage*, 1815

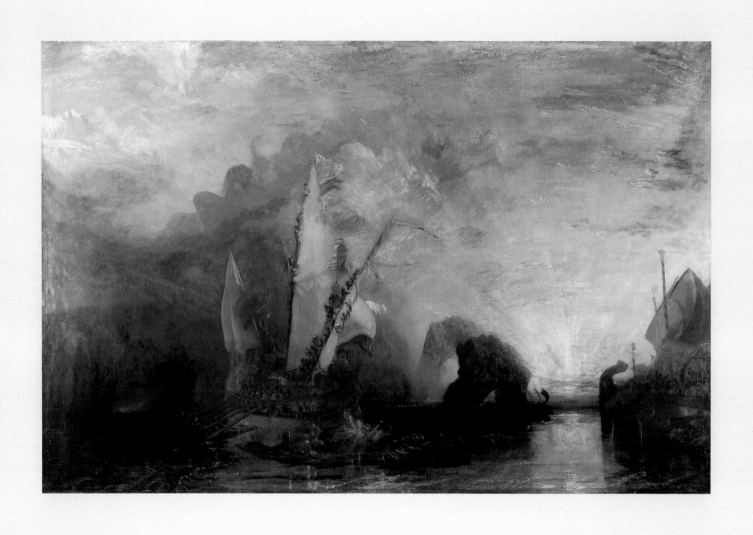

33 Joseph Mallord William TURNER (1775–1851)
Ulysses deriding Polyphemus – Homer's Odyssey, 1829

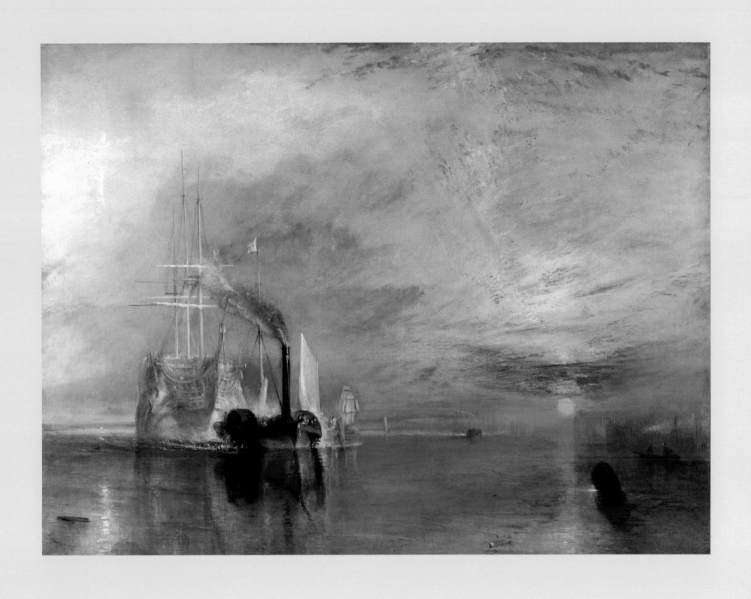

34 Joseph Mallord William TURNER (1775–1851) *The Fighting Temeraire*, 1839

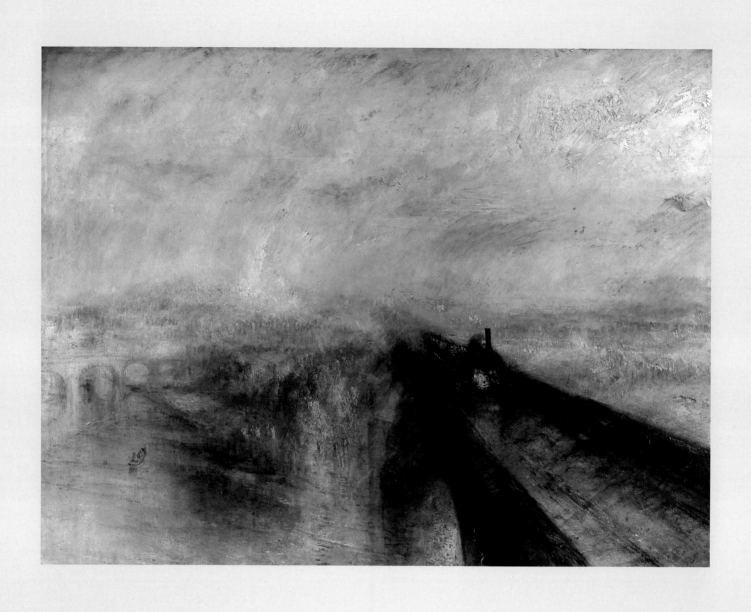

35 Joseph Mallord William TURNER (1775–1851)
Rain, Steam, and Speed – The Great Western Railway, 1844

36 Joseph Mallord William TURNER (1775–1851) *Margate (?), from the Sea*, about 1835–40

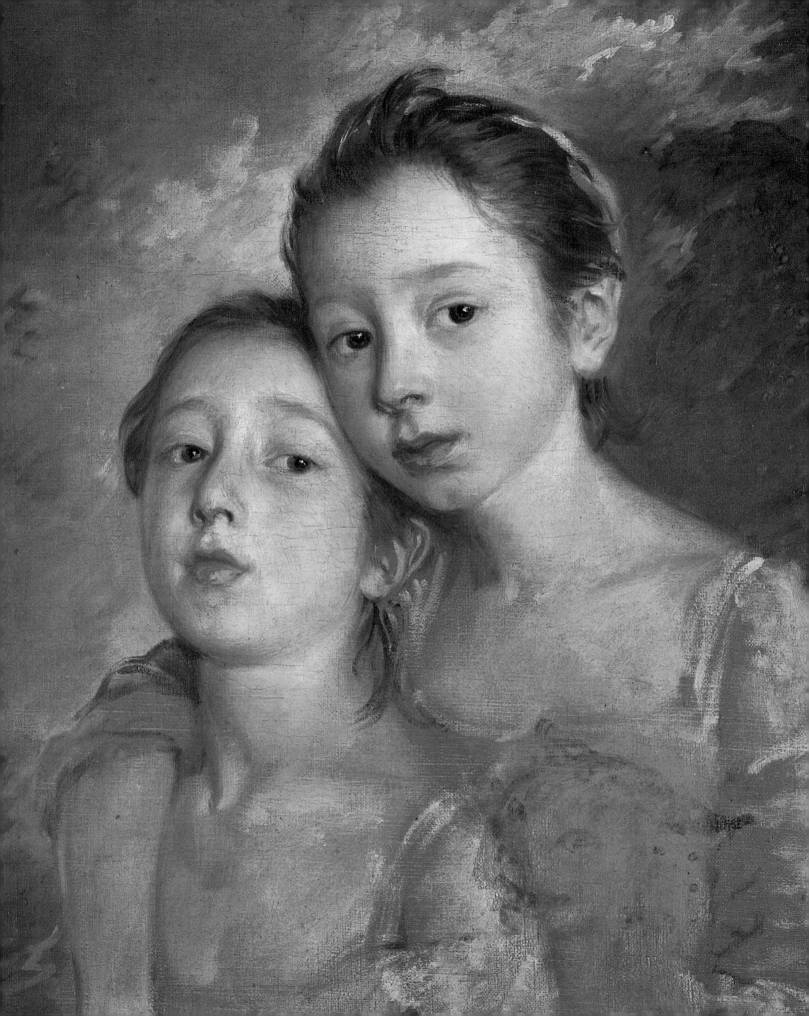

1 William HOGARTH (1697–1764)
Marriage A-la-Mode: 1, The Marriage Settlement, about 1743
Oil on canvas, 69.9 x 90.8 cm
Bought, 1824

This is the first of six paintings in Hogarth's innovative 'modern' moral tale warning against marriages arranged for the benefit of parents. The Earl of Squander holds court in his bedchamber, proudly gesturing to a family tree which appears literally to spring from William the Conqueror. He has nobility but no money, as both his name and the view through the window of his unfinished new house suggest. The city Alderman in the red coat has money but craves a higher social status. The fathers prepare to exchange cash for class through the marriage of their children.

This approach is fatally flawed. The young couple show no interest in each other. The Viscount admires his own reflection, abandoning his dejected bride to the predatory attentions of a lawyer named Silvertongue. Two dogs sum up the situation: usually a sign of willing fidelity, here they are shackled together and miserable.

2 William HOGARTH (1697–1764)
Marriage A-la-Mode: 6, The Lady's Death, about 1743
Oil on canvas, 69.9 x 90.8 cm
Bought, 1824

Four subsequent paintings have described the couple's descent into infidelity, chaos and tragedy. In this final scene, we are in the Alderman's home. His daughter has committed suicide after reading that her lover, the lawyer Silvertongue, has been executed after killing her husband. The doctor berates a servant, accusing him of procuring the poison for the Countess, but Hogarth blames the father. He shows the Alderman calmly removing his daughter's wedding ring just as she expires, more concerned with taking her property than saying goodbye.

Hogarth also includes one last appalling consequence of this doomed marriage: the couple's sickly child is now an orphan. A starving dog points to the moral of this tale by sinking his teeth into the ear of a pig's head on the table. This marriage could never have been a 'silk purse', because it was from the start a 'sow's ear'. Hogarth believed that his art could change society; his prints showing the terrible effects of gin-drinking were in fact part of a successful campaign to change licensing laws.

3 William HOGARTH (1697–1764)
The Graham Children, 1742
Oil on canvas, 160.5 x 181 cm
Presented by Lord Duveen through The Art Fund, 1934

Hogarth's portraits are both lifelike and full of meaning. These are the children of the wealthy apothecary Daniel Graham. Hogarth has captured their sheer delight as they play: Anna rustles the skirts of her flowered dress, ready to dance, while baby Thomas, in a dress, reaches for some enticing cherries in Henrietta's hand. Richard winds the handle of a bird-organ, to encourage their caged bullfinch to sing.

However, this state of childhood innocence is fragile. The clock in the background, topped by a cherub with a scythe and hourglass, suggests that this carefree time will end. Henrietta is on the cusp of adolescence, and one day Richard will realise that the bird is not chirping happily, but is terrified by the cat. Young Thomas died while Hogarth was working on the portrait; the stems on the fruit and flowers next to him have been cut short to reflect his brief life. Hogarth's painting preserves a beautiful memory of a childhood that in reality could never be assured.

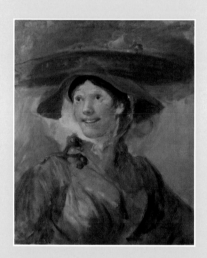

4 William HOGARTH (1697–1764)
The Shrimp Girl, about 1740–5
Oil on canvas, 63.5 x 52.5 cm
Bought, 1884

This evocative sketch depicts a shellfish seller with a basket on her head containing a loosely suggested heap of shrimps and mussels, and a half-pint measure. Hogarth seems to have painted her rapidly from life for his own pleasure or practice. He never sold this canvas; later his widow used it to rebuff critics: 'They say he could not paint flesh and blood. There's flesh and blood for you!'

It shows what Hogarth valued most in art: observation, vitality, curving serpentine lines, and a genuine feeling for paint. He argued in his aesthetic theories that the principal object of study for an artist should not be 'the stony features of a venus' but a 'blooming young girl of fifteen'. Moreover, 'if a thing is good, the action and the passion may be more truly and distinctly conveyed by a coarse bold stroke than the most delicate finishing.'

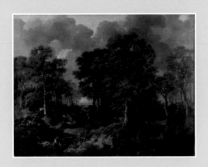

5 Thomas GAINSBOROUGH (1727–1788)
Cornard Wood, near Sudbury, Suffolk, 1748
Oil on canvas, 122 x 155 cm
Bought (Lewis Fund), 1875

Thomas Gainsborough taught himself to draw by copying Dutch landscapes, particularly those of Jacob van Ruisdael. In his early works, he treated his native Suffolk countryside just as a Dutch seventeenth-century master might, focusing on attractive clumps of trees, tangles of undergrowth and grey skies reflected in quiet pools. People are shown making the most of this land: grazing donkeys, collecting wood or sand, and taking the path to the distant village of Great Henny, whose church is visible on the horizon.

Such landscapes would come to be seen as 'picturesque', appreciated because they rejected classical ideals and found beauty instead in the wild foliage, rutted tracks and irregular forms of the British countryside. For Gainsborough, this painting meant new opportunities. He later wrote that 'it was begun before I left school; – and was the means of my Father's sending me to London'. It marked the beginning of a highly successful career.

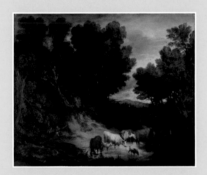

6 Thomas GAINSBOROUGH (1727–1788)
The Watering Place, before 1777
Oil on canvas, 147.3 x 180.3 cm
Presented by Charles Long MP, later Lord Farnborough, 1827

In his later landscapes, Gainsborough no longer focused on specific views. Instead, he took motifs such as dense trees, sandy cliffs, shimmering water, peasants and placid animals, and combined them into picturesque compositions. He was inspired here by Peter Paul Rubens's *'The Watering Place'* (about 1620, London, National Gallery), which he had admired in the Duke of Montagu's collection. Gainsborough transformed Rubens's industrious herdsmen and hearty cattle into softer, dreamier forms.

This was the first work by Gainsborough to enter the National Gallery, and it seems to have divided opinion. Unimpressed, an anonymous reviewer for *Blackwood's Magazine* wrote that this '"Watering Place" is but a dingy ditch, with stained cattle ... fearful to drink, or lie down, in the unpromising liquid'. However, the German artist Johann David Passavant praised it as one of Gainsborough's 'finest productions ... displaying a depth, a juicyness and playfulness of colouring which is highly pleasing to the eye'.

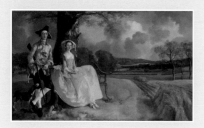

7 Thomas GAINSBOROUGH (1727–1788)
Mr and Mrs Andrews, about 1750
Oil on canvas, 69.8 x 119.4 cm
Bought with contributions from the Pilgrim Trust, The Art Fund,
Associated Television Ltd, and Mr and Mrs W.W. Spooner, 1960

Gainsborough was famed for both his portraits and his landscapes; this early work combines these elements in an 'outdoor conversation piece'. It shows Robert Andrews, whom Gainsborough had known at school, with his wife Frances. They are depicted against a backdrop of their farm, Auberies. It is unusually specific, almost a portrait of the land as much as the sitters. In fact, the marriage had been arranged by the couple's fathers to join two adjacent estates, so land was central to their union.

Mr Andrews leans casually on the decorative bench, his pose taken from an etiquette book which advised gentlemen on how to appear 'at ease'. His hunting apparel presents him as a landowner. Frances wears a fashionably rustic 'bergère' or shepherdess hat, although her pink satin slippers confirm that she performs no such role in reality. The oak tree and sheaves of corn are realistic details (the tree still exists) which also symbolise their hope for a family.

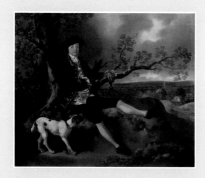

8 Thomas GAINSBOROUGH (1727–1788)
John Plampin, probably about 1752
Oil on canvas, 50.2 x 60.3 cm
Bequeathed by Percy Moore Turner, 1951

This engaging portrait shows John Plampin on his family's land: the church in the distance behind him is recognisably All Saints, Lawshall, near his family seat of Chadacre Hall, in the manor of Shimpling. His relaxed pose draws on earlier paintings by the Frenchman Antoine Watteau and Gainsborough's friend, Francis Hayman. His hand tucked into his waistcoat follows the rules set by masters of deportment, but the splayed legs suggest a certain degree of rebellion: this confident young man will sit as he pleases.

It has been argued that such portraits used landscape subtly to reinforce ideas about British social order. Landed gentry are shown apparently at ease in the land that they own; nature is then used to present their authority and privilege as somehow 'natural'.

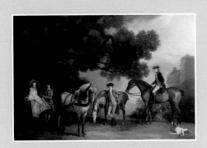

9 George STUBBS (1724–1806)
Sir Peniston and Lady Lamb, later Lord and Lady Melbourne, with Lady Lamb's Father, Sir Ralph Milbanke, and her Brother John Milbanke ('The Milbanke and Melbourne Families'), about 1769
Oil on canvas, 97.2 × 147.3 cm
Bought, 1975

George Stubbs brought an expertise in equine painting to the 'outdoor conversation piece': here Sir Penistone Lamb has a glossy chestnut Arabian mount that is as much a part of this family portrait as the humans. The horses seem to echo their owners' roles: Sir Penistone's proud steed dominates John Milbanke's quiet grey, as Lady Lamb's pony waits patiently in its harness. Sir Ralph Milbanke is a protective presence by his daughter's side; she was probably pregnant when this portrait was painted.

Her marriage united the Milbankes, a respected Yorkshire family, with the vast quantities of 'new' money earned by the Melbournes through land conveyancing and money-lending. As Lady Melbourne, Elizabeth Milbanke became notorious as a ruthless social climber with many different lovers. In her sixties, she was a confidante of the poet Byron. He described her conversation as 'champaigne' for his spirits, and confessed: 'I have often thought, that, with a little more youth, Lady M. might have turned my head.'

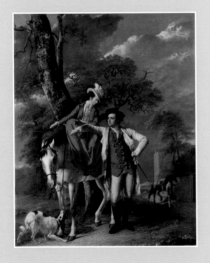

10 Joseph WRIGHT 'of Derby' (1734–1797)
Mr and Mrs Thomas Coltman, about 1770–2
Oil on canvas, 127 × 101.6 cm
Bought with contributions from the National Heritage Memorial Fund and the Pilgrim Trust, 1984

Compared with the prim formality of Gainsborough's *Mr and Mrs Andrews* (no. 7), Joseph Wright's portrait of Thomas and Mary Coltman seems openly affectionate. They prepare for a ride outside Gate Burton Hall, their rented home in Lincolnshire. Clad in breeches so tight we can see the outline of a coin in his pocket, Coltman leans happily against his wife's thigh as she turns attentively towards him. Wright may have relaxed some of the usual portraiture conventions because his sitters were also great friends from his home town of Derby. Coltman even helped to fund the artist's two-year trip to Italy. Wright spent some time in Bath, hoping to succeed Gainsborough as a fashionable portraitist, but failed to make his mark. He had more impact when he was based in Derby and exhibiting in London; his dramatic 'candlelight pictures' (see no. 11) attracted particular attention.

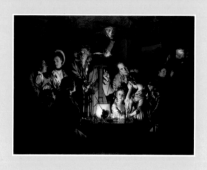

11 Joseph WRIGHT 'of Derby' (1734–1797)
An Experiment on a Bird in the Air Pump, 1768
Oil on canvas, 183 x 244 cm
Presented by Edward Tyrrell, 1863

Wright was fascinated by light effects, from glowing hot metal and candle flames to fireworks and erupting volcanoes. Inspired by Dutch painters who had developed Caravaggio's dramatic contrasts of dark and light, Wright plunged his scenes into velvety shadow enlivened by carefully chosen light sources. Here, a hidden candle illuminates a scientific demonstration. Air has been pumped out of a glass container, so the bird within falls into a faint. The 'natural philosopher' (fig. 4) raises his hand to the tap which will let in air to revive the bird – but is it too late?

The spectators react in a range of ways appropriate to their age and gender. The painting poses major questions: is it right that scientific knowledge allows this demonstrator to toy with the bird's life? Should anyone play God in this way? The scene's lighting reflects both the brilliance of enlightened discovery and the moral shadows that it may bring.

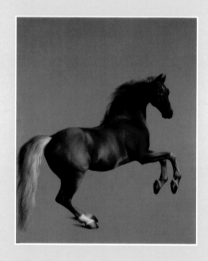

12 George STUBBS (1724–1806)
Whistlejacket, about 1762
Oil on canvas, 292 x 246.4 cm
Bought with the support of the Heritage Lottery Fund, 1997

A self-taught artist from Liverpool, George Stubbs devoted years to the messy and laborious process of dissecting horse carcasses, recording his observations in detailed drawings that when published became essential reading for vets and horse breeders. His extensive knowledge made him the perfect artist for wealthy owners, such as the Marquess of Rockingham, who was to commission twelve works from Stubbs.

Whistlejacket was Rockingham's superb example of an Arabian thoroughbred, and Stubbs knew exactly which features to detail: the small tapering head, large nostrils, curved ears and powerful body which signalled his heritage. The plain background looks unfinished, but was probably intentional. It gives the portrait a classical air, something which would have suited both Rockingham (who had a collection of classical sculptures) and the artist (who had visited Rome and had grand ambitions for his work). The flat background also makes Whistlejacket's form appear even more three-dimensional. It is almost as if this unsettled stallion could at any moment gallop out of the picture frame.

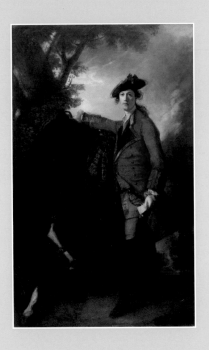

13 Sir Joshua REYNOLDS (1723–1792)
Captain Robert Orme, 1756
Oil on canvas, 239 × 147 cm
Bought, 1862

Reynolds made this portrait near the beginning of his career, as a speculative gamble that he hoped would bring publicity and perhaps some payment. Captain Robert Orme is shown during the war against the French for supremacy in the North American colonies: the smoke behind him suggests the battle he has just left. Exhausted, he prepares to mount his horse to report the devastating news that General Edward Braddock had just been killed.

He is shown as a very human hero, haunted by what he has seen but still firm and upright. Reynolds drew inspiration for the horse's bowed head from a Renaissance fresco by Jacopo Ligozzi (1547–1627) that he had sketched in Florence, the kind of learned reference that he believed elevated art. Orme did not buy the portrait, but it attracted positive attention in Reynolds's studio, where it was displayed for more than 20 years as an example of what the artist could do.

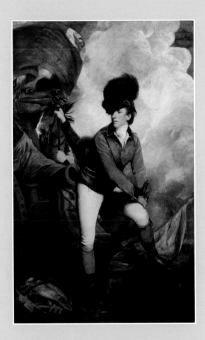

14 Sir Joshua REYNOLDS (1723–1792)
Colonel Tarleton, 1782
Oil on canvas, 236 × 145.5 cm
Bequeathed by Mrs Henrietta Charlotte Tarleton, 1951

By the time Reynolds painted this portrait, he had been knighted and was the first President of the Royal Academy of Arts. He continued to weave allusions to classical art into his portraits wherever possible. Here, Reynolds has given Tarleton a coiled pose that makes him appear ready to spring into action, and connects him to an ancient statue in the Louvre then thought to represent the Roman general Cincinnatus. Tarleton's pose also draws discreet attention to the fact that he lost two fingers in battle, and needed both hands to draw his sword.

Known for his reckless and sometimes savage tactics in war, Tarleton lived a scandalous life back in Britain. Horace Walpole reported that Tarleton boasted of having 'lain with more women than anybody'. Later Tarleton became a politician, and was an ardent defender of slavery, the source of his family's fortune. This portrait was commissioned by Tarleton's brother for their mother, so perhaps unsurprisingly presents an idealised version of him, as an oasis of calm resolve in the swirl of battle.

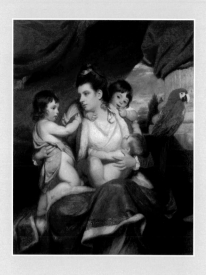

15 Sir Joshua REYNOLDS (1723–1792)
Lady Cockburn and her Three Eldest Sons, 1773
Oil on canvas, 141.5 × 113 cm
Bequeathed by Alfred Beit, 1906

Reynolds's portraits offered his sitters a certain seriousness. He was convinced that ladies should never be painted in modern dress: 'the familiarity alone is sufficient to destroy all dignity'. His approach also offered the chance to communicate more complex ideas. When Sir James Cockburn ordered a portrait of his wife and their three eldest sons, Reynolds designed an image that suggested Lady Cockburn personified the virtue of Charity, the ultimate mother who selflessly cares for others. She is usually shown holding several children, with one at her breast.

Reynolds was inspired in particular by a painting of *Charity* by Sir Anthony van Dyck (fig. 6). He also borrowed the pose of the eldest boy from Cupid in Velázquez's *Rokeby Venus* (1647–51, London, National Gallery), known to Reynolds through a drawing by Richard Cooper. Lady Cockburn appears therefore as virtuous, as a most caring mother and also as a goddess.

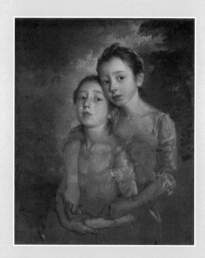

16 Thomas GAINSBOROUGH (1727–1788)
The Painter's Daughters with a Cat, probably about 1760–1
Oil on canvas, 76.5 × 62.9 cm
Bought, 1923

This painting has none of the constraints of a portrait commission: it is simply a father's sketch of his two young daughters, Mary and Margaret. As such, it is intimate and immediate, the girls' arms and their cat barely sketched in. They are shown in natural, relaxed poses, far more informal than the compositions that Gainsborough devised for his portraits of other people's children. Mary and Margaret are in a different realm altogether from Reynolds's artfully posed youngsters.

The unfinished nature of this work allows us to see something of Gainsborough's working method. The pinkish-brown ground colour is visible in the lower right corner. The initial design has been sketched directly onto it with both a white substance that could be a form of china clay pastel, and a diluted brownish-black paint. Loose brushstrokes over the top then build up forms that are defined through colour, light and dark rather than line.

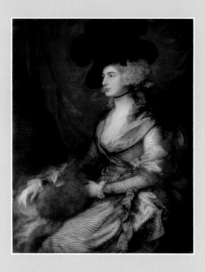

17 Thomas GAINSBOROUGH (1727–1788)
Mrs Siddons, 1785
Oil on canvas, 126 x 99.5 cm
Bought, 1862

Sarah Siddons was the greatest tragic actress of her day, and was portrayed by many artists. Usually they made some reference to her profession, often depicting her in one of her famous roles. Gainsborough's portrait is completely different: she appears as herself, a quiet, rather haughty fashionable lady. Gainsborough differentiated himself from his rival Reynolds by making a feature of contemporary dress in his portraits. Mrs Siddons wears a 'wrapping gown' tied at the waist with a sash, a very practical outfit for an actress.

The drama in her portrait is to be found in the lively colours and broken brushstrokes. Anecdotes suggested that Gainsborough struggled with her famous profile, grumbling 'confound the nose, there's no end to it'. The painting itself, however, shows no pentimenti (painted-out mistakes), so the stories are probably part of the teasing about her long nose that Mrs Siddons endured as a high-profile celebrity.

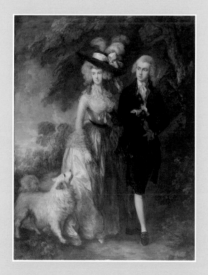

18 Thomas GAINSBOROUGH (1727–1788)
Mr and Mrs William Hallett ('The Morning Walk'), 1785
Oil on canvas, 236.2 x 179.1 cm
Bought with a contribution from The Art Fund (Sir Robert Witt Fund), 1954

William Hallett and Elizabeth Stephen commissioned Gainsborough to paint this portrait shortly before their marriage. A commentator in *The Times* later described it as 'a perfect realisation of youthful elegance and high breeding ... before the turf and the bottle has soured the husband's brow, and reddened his nose, or the gout stiffened and swelled those shapely legs of his.' Indeed, the couple's life together would be plagued by problems.

A comparison with *Mr and Mrs Andrews* (no. 7) shows how Gainsborough's technique had changed over the decades. Relaxed, yet with their faces composed into perfect masks of politeness, the couple stroll along a woodland path. However, this is no solid portrait of their own land. Instead, the foliage settles into a multi-layered composition of clouds, gauzy fabrics, feathers, soft hair and fluffy fur, in a dazzling display of Gainsborough's extraordinary ability to apply paint in loose, suggestive ways.

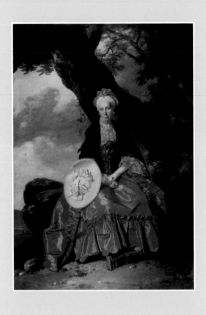

19 Johann ZOFFANY (1733?–1810)
Mrs Oswald, about 1763–4
Oil on canvas, 226.5 x 158.8 cm
Bought, 1938

The German painter Johann Zoffany arrived in England in 1760, and became a favourite of King George III and Queen Charlotte. The King himself nominated Zoffany as a member of the Royal Academy of Arts, and commissioned him to paint a group portrait of the academicians in 1772.

Such royal patronage recommended him to the gentry, and he established a solid portraiture practice. This painting of Mrs Oswald was destined for her family home in Auchincruive, Ayrshire. The artist attempted to enliven his sitter's rather dour appearance with a youthful straw hat from his studio, but to little effect. Mrs Oswald grew up in Jamaica, heiress to a fortune made from sugar and slavery. In Ayrshire, she was seen by some as cold and miserly. The poet Robert Burns noted: 'I spent my early years in her neighbourhood, and among her servants and tenants I know she was detested with the most heart-felt cordiality.'

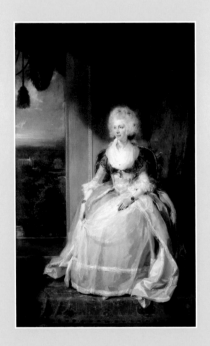

20 Sir Thomas LAWRENCE (1769–1830)
Queen Charlotte, 1789
Oil on canvas, 239.5 x 147 cm
Bought, 1927

Lawrence was a child prodigy, toured by his father to support the family. Encouraged by Sir Joshua Reynolds, he trained briefly at the Royal Academy Schools. He was only 20 years old when he was summoned to Windsor Castle to paint Queen Charlotte. She perhaps wanted a portrait as a statement of loyalty to her husband, who had recently been seriously ill; she conspicuously wears two bracelets decorated with George's portrait and cipher. Charlotte was exhausted and ill-tempered, and found the young artist 'most impertinent'. She arrived to sit wearing a bonnet, and when he objected she decided to sit bare-headed, but she found the end result immodest and did not buy the painting.

Although Lawrence was Reynolds's protégé, it is clear from this portrait that he followed Gainsborough's expressive approach to paint. He turned Charlotte's dull grey gown into a shimmering mass of violets and blues, suggesting lace and veils with deceptive ease.

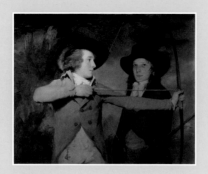

21 Sir Henry RAEBURN (1756–1823)
Robert Ferguson of Raith 1770–1840 and Lieutenant General Sir Ronald Ferguson 1773–1841 ('The Archers'), about 1789–90
Oil on canvas, 110.5 × 123.6 cm
Acquired under the acceptance-in-lieu procedure, 2001

Sir Henry Raeburn managed an international career from his home in Edinburgh. Known for his inventive portraits, he used the Ferguson brothers' interest in the fashionable sport of archery as the basis for this intricate composition, setting up a series of intersecting straight and curved lines. Robert, the elder brother, occupies the prime position at the front of the painting. He is shown both as a man of action and as a gentleman in the making, with his fashionably unbuttoned coat and powdered hair. Ronald is shown literally in his older brother's shadow, his bow as yet unstrung. This is no passive second son, however: he engages the viewer with a direct gaze.

Raeburn made this portrait early in his career, when he was experimenting with unusual compositions and lighting effects. He also explored ideas from the art of the past, in this case adapting elements from Van Dyck's imposing yet still sensitive portraits of brothers.

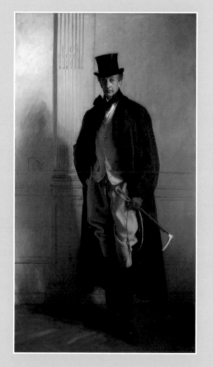

22 John Singer SARGENT (1856–1925)
Lord Ribblesdale, 1902
Oil on canvas, 258.4 × 143.5 cm
Presented by Lord Ribblesdale in memory of Lady Ribblesdale and his sons, Captain the Hon. Thomas Lister and Lieutenant the Hon. Charles Lister, 1916

An American based for most of his career in London, Sargent was inspired by Reynolds's full-length 'Grand Manner' portraits. He reinvented them for his own age, and found no shortage of clients wishing to be portrayed in this elegant, striking manner. In this case, however, it was the artist who initially approached Lord Ribblesdale, intrigued by the lean lines of his silhouette.

Ribblesdale appears in his unconventional hunting clothes: he professed to hate scarlet coats because they brought an unnaturally gaudy note into the beauty of the countryside. Sargent almost certainly requested the addition of the black topcoat, and used long, vigorous brushstrokes to define its edges. The portrait was praised for the way that it captured Ribblesdale's dignity and unaffected character; when he died in 1925, *The Times* chose to reproduce Sargent's portrait rather than a more recent photograph.

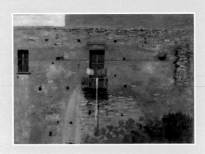

23 Thomas JONES (1742–1803)
A Wall in Naples, about 1782
Oil on paper laid on canvas, 11.4 x 16 cm
Bought, 1993

Thomas Jones trained with Richard Wilson (see no. 25), painting large classical landscapes and views of his native Wales. He spent seven years in Italy, working in Rome and Naples, but was not as successful with Grand Tour patrons as he had hoped. He had two children with his companion Maria Moncke, and little money, so long sketching trips in the countryside were no longer possible. For his own interest and pleasure, Jones made small oil studies of buildings observed from rooftops or windows. These were forgotten until their rediscovery in 1956, when they were celebrated for their originality.

The viewpoint is unconventional, making the narrow strip of intense blue sky part of a geometric pattern of rectangular shapes. Through his close scrutiny, Jones has found beauty in crumbling plaster, in irregular stonework studded with moss and pockmarked with scaffolding holes, in wet laundry and even in the pale stains from many emptied chamber pots.

24 Frederic, Lord LEIGHTON (1830–1896)
The Villa Malta, Rome, 1860s
Oil on canvas, 27.2 x 41.5 cm
The Gere Collection, on long-term loan to the National Gallery

A great admirer of the Italian Renaissance, Frederic, Baron Leighton of Stretton spent time in Italy studying its buildings and altarpieces at first hand. He is best known now for his large-scale figure paintings, but he often sketched the places to which he travelled. Leighton had been impressed by the landscapes of the French painter Corot, who worked out of doors, trying to capture the effects of light, water and rustling foliage in the countryside around him.

In this sketch, Leighton seems to have been interested in the way that the monumental forms of the cypress trees in the foreground frame but also dwarf the tall tower of the Villa Malta in the centre. The composition explores the interplay between light and dark, horizontals and verticals, natural and constructed forms. Oil sketches were often a place of experimentation; many artists felt free to explore different ideas in this small, private format.

25 Richard WILSON (1713/14–1782)
Holt Bridge on the River Dee, before 1762
Oil on canvas, 148.5 x 193 cm
Bought, 1953

Welsh artist Richard Wilson's speciality was idealised landscape in the manner of the French seventeenth-century master Claude Lorrain. Claude's method had been to sketch individual elements from the countryside around his base in Rome, from trees and hillsides to recognisable architectural features, and then to combine them into a tranquil, harmonious composition bathed in golden light.

Using a similar approach, Wilson has transformed the River Dee, the border between England and Wales, into an arcadian idyll. Unconcerned with strict topography, he has made the hills higher to add variety and interest, and has invented the foreground entirely. This gives him the opportunity to include a Claudian tree which frames the fourteenth-century bridge in the distance, and provides shade for the rustic figures enjoying the uncharacteristically warm Cheshire sun.

26 John CONSTABLE (1776–1837)
Stratford Mill, 1820
Oil on canvas, 127 x 182.9 cm
Acquired under the acceptance-in-lieu procedure, 1987

John Constable loved the Suffolk landscape in which he grew up, and felt keenly that it needed neither to be radically altered and washed in Italian light, nor to have its more picturesque features exaggerated (see nos 25, 5 and 6). 'There is room enough for a natural painture', he insisted. He sketched different elements out of doors, but combined them into compositions that were recognisable Suffolk locations. This shows Stratford Mill, a water-powered paper mill on an islet in the River Stour.

Yet Constable always aimed to do more than simply paint the countryside of his youth. This place is beautiful, but he also shows that it is productive, fuelling industry and providing food and water as well as cool respite on a hot day. He felt that landscape painting should have a higher status, and set out to demonstrate its value through a series of large canvases known as the 'six-footers': this is the second shown at the Royal Academy.

27 John CONSTABLE (1776–1837)
The Hay Wain, 1821
Oil on canvas, 130.2 x 185.4 cm
Presented by Henry Vaughan, 1886

The Hay Wain was the third in Constable's monumental 'six-footer' series, a determined bid for attention. It was constructed through a process of sketching and refinement that mirrored the best practice of leading continental history painters. Some of Constable's changes have become visible over time: for example, we can see that there was originally a barrel on the river bank to the right of the dog. The composition centres on a wagon going to collect hay from the workers on the right, represented by tiny dots of paint just below the trees.

Constable was fascinated by the interplay of light and shadow in landscape, writing a theoretical treatise on the 'chiaroscuro of nature'. Here he has suggested sparkling highlights on water with rough touches of white paint. While his colleagues in London were largely unimpressed, painters in France were struck by this technique. It would inform their own changing approach to capturing fleeting natural effects in paint.

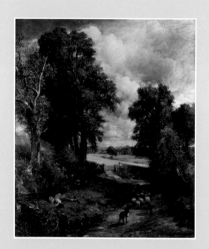

28 John CONSTABLE (1776–1837)
The Cornfield, 1826
Oil on canvas, 143 x 122 cm
Presented by subscribers, including Wordsworth, Faraday and Sir William Beechey, 1837

Public recognition for Constable's work was painfully slow. Paintings that may seem traditional to viewers now were considered challenging in the 1820s. Short of money and struggling to finish an ambitious view of Waterloo Bridge, Constable sent this work to the 1826 Royal Academy exhibition, writing to his friend Fisher: 'I do hope to sell this present picture – as it has certainly got a little more eye-salve than I usually condescend to give to them.'

Although reviewers were mostly positive, this appealing scene failed to find a buyer at any of the five exhibitions to which the artist sent it over the next ten years. Soon after Constable's death in 1837, a group of his friends raised enough money from subscriptions to buy *The Cornfield* from his studio, and presented it to the National Gallery, the first work by him to enter the collection.

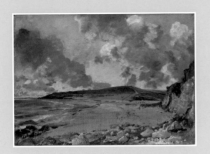

29 John CONSTABLE (1776–1837)
Weymouth Bay: Bowleaze Cove and Jordon Hill, 1816–17
Oil on canvas, 53 × 75 cm
Salting Bequest, 1910

This is one of several sketches that Constable made while on his honeymoon. It shows his favourite combination of both wild nature and landscape that is visibly managed by man. It may well have been painted outside: it is of a similar size to canvases Constable used for sketching trips, and he appears to have worked quite quickly. He has left the 'ground' or base colour uncovered to represent the beach, and has worked 'wet in wet', blending fresh paint into existing layers that had not yet dried.

Painting outdoors was far more difficult in Constable's day than it would be for the French Impressionists 50 years later. Collapsible metal paint tubes had not yet been invented, so Constable had to premix the paints himself and transport them in pigs' bladders. Once cut open, they could not be resealed, so this was a messy and expensive practice.

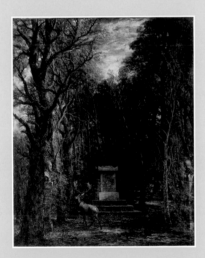

30 John CONSTABLE (1776–1837)
Cenotaph to the Memory of Sir Joshua Reynolds, erected in the grounds of Coleorton Hall, Leicestershire, by the late Sir George Beaumont, Bt, 1833–6
Oil on canvas, 132 × 108.5 cm
Bequeathed by Miss Isabel Constable as the gift of Maria Louisa Isabel and Lionel Bicknell Constable, 1888

Although Constable was frustrated by some of the values that Reynolds had embedded within the British art establishment, he had enormous respect for his achievements. It was Constable's choice to paint a noble stag wandering into Sir George Beaumont's wooded memorial to Reynolds, stopping to look up at the busts of Michelangelo and Raphael which framed the cenotaph. He has made the avenue of lime trees around it into a kind of natural cathedral, echoing the 'darksome aisle' described by Wordsworth in the text carved into the monument.

This late painting shows how unorthodox Constable's technique could be. *Blackwood's Magazine* condemned it as 'scratchy and uncomfortable' and 'ill-suited to the subject', 'utterly ruinous to the sentiment'. Only *The Morning Chronicle*'s reviewer noted that 'by choosing a proper distance for observing ... by degrees the effect seems to grow upon us.'

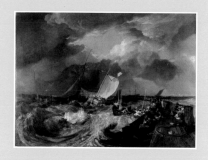

31 Joseph Mallord William TURNER (1775–1851)
Calais Pier, with French Poissards preparing for Sea: an English Packet arriving, 1803
Oil on canvas, 172 x 240 cm
Turner Bequest, 1856

In this early seascape, Turner paid homage to the Dutch seventeenth-century masters of the genre, but added even more drama. An English packet or mail boat laden with passengers is trying to dock in high winds at Calais pier. The diagonals in the composition add to the sense of instability conveyed by the heaving sea. Turner was fascinated by the sublime power of nature. He may also have been commenting on the fragile state of the peace between France and England at the time, and possible stormy seas ahead. Indeed, war broke out again just sixteen days after this work went on show.

The son of a London barber, Turner taught himself to paint. He was just as ambitious for landscape painting as Constable, but his talents were recognised far sooner: he was only 26 when he became a member of the Royal Academy. The critics, however, disliked his technique, complaining that this sea looked like soap, chalk, smoke and batter, but not water.

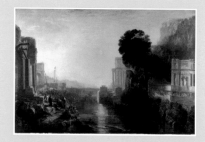

32 Joseph Mallord William TURNER (1775–1851)
Dido building Carthage, or The Rise of the Carthaginian Empire, 1817
Oil on canvas, 155.5 x 230 cm
Turner Bequest, 1856

Turner was inspired by the past just as much as by nature. The rise and fall of the ancient empire of Carthage fascinated him throughout his life. Here he shows Dido, a tiny crowned figure bathed in light, supervising the construction of her glittering new domain. Turner has deliberately echoed Claude's seaports in his choice of classical buildings and a central reflected sun. When he left this painting to the National Gallery, he stipulated that it be hung with work by Claude, to show that he owed a great debt to the earlier artist.

He often retouched work, particularly during the 'varnishing days' at the start of the Royal Academy's annual exhibition. The *Sun*'s critic noted that the bright yellow sunlight here had been toned down since he last saw it. Turner would often add glazes or touches of colour so that his works stood out from those hanging nearby, much to the annoyance of other artists.

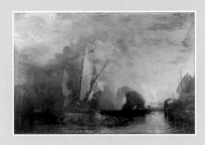

33 Joseph Mallord William TURNER (1775–1851)
Ulysses deriding Polyphemus – Homer's Odyssey, 1829
Oil on canvas, 132.5 × 203 cm
Turner Bequest, 1856

Turner believed that landscape could represent almost any idea, feeling or narrative. Here, he developed sketches of rock formations made in Italy into a scene which expresses the triumphant defiance of a man who has overcome extraordinary obstacles. Ulysses and his men have just escaped from the giant Cyclops Polyphemus, by blinding his single eye with a flame torch. The hero is shown as a tiny figure in red, punching the air; it is the entire sky that communicates his exuberance. *The Athenaeum* admired its 'poetic feeling', but *The Morning Herald* felt that it was 'colouring run mad … with all the vehement contrasts of a kaleidescope'.

The artist may have seen something of himself in Ulysses, battling against powerful figures in social as well as artistic terms: he was mocked for his Cockney accent and abrupt manners. Constable sat next to Turner at a Royal Academy dinner in 1813, and noted 'he is uncouth but has a wonderfull range of mind'.

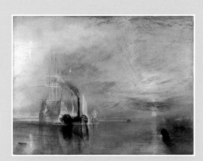

34 Joseph Mallord William TURNER (1775–1851)
The Fighting Temeraire tugged to her last berth to be broken up, 1838, 1839
Oil on canvas, 90.7 × 121.6 cm
Turner Bequest, 1856

This is the last journey of the 'Fighting Temeraire', a celebrated gunship which had fought valiantly in Lord Nelson's fleet at the battle of Trafalgar in 1805. Thirty-three years later, decaying and no longer in use, she was towed up the Thames to be broken up in a Rotherhithe shipyard.

A fiercely patriotic artist, Turner wanted to pay tribute to her heroic past, using artistic licence to communicate particular messages. The glorious sunset is a fanfare of colour in her honour. He used recently developed pigments including lemon yellow and bright iodine scarlet, laid on in slabs of pure colour. The sunset can also be seen as a symbol of the end of an era, as the age of elegant, tall-masted warships draws to a close. The 'Temeraire' is already a ghostly shape, fading away behind the solid form of the squat little steam tug that pulls her along to her fate.

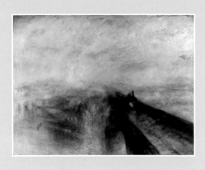

35 Joseph Mallord William TURNER (1775–1851)
Rain, Steam, and Speed – The Great Western Railway, 1844
Oil on canvas, 91 x 121.8 cm
Turner Bequest, 1856

By the 1840s, the effects of industrialisation on the British landscape were becoming apparent. Turner's response was ambiguous. Here, Brunel's Maidenhead Railway Bridge is a dark gash across a shimmering expanse of water and misty air; yet it is also an undeniably dynamic form, appearing to hurtle out towards the viewer. Turner has set up a series of contrasts: between the train, a boat and the old road bridge, and between the power of steam and the natural forces of wind and rain. He has also painted a tiny hare running in front of the train, leaving it to the viewer to decide if it is about to be crushed, or is in fact out-running the train.

Turner used a wide range of painting techniques, from thin oil glazes inspired by his work in watercolour, to thick textured 'impasto' applied with a palette knife as well as brushes.

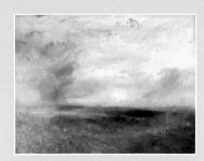

36 Joseph Mallord William TURNER (1775–1851)
Margate (?), from the Sea, about 1835–40
Oil on canvas, 91.2 x 122.2 cm
Turner Bequest, 1856

The sea was a subject which Turner painted obsessively, sketching out of doors and making larger works in his studio. He was particularly familiar with the coast around Margate, staying there often with his long-term companion Mrs Booth, who owned a house above the harbour. During the late 1830s, he was interested in exploring how the sea and skies changed with the weather, and tried to capture the effect of storms on air and water.

This is one of many works left in Turner's studio when he died in 1851, and considered at the time to be too unfinished for public display. It seems now to be an experimental representation of atmospheric effects which foreshadows the work of the French Impressionists. Turner's work was innovative at an internationally significant level, and shows just how far British artistic ambitions and achievements had come since the beginning of the eighteenth century.

HOGARTH TO TURNER is one in a series of books focusing on highlights of the National Gallery Collection.

Other titles in the series include:

MANET TO PICASSO
MODERN FRENCH PAINTING
Christopher Riopelle,
with Charlotte Appleyard,
Sarah Herring, Nancy Ireson
and Anne Robbins
ISBN 978 1 85709 333 9

DUTCH PAINTING
REMBRANDT TO VERMEER
Marjorie E. Wieseman,
with Elena J. Greer
ISBN 978 1 85709 358 2

COROT TO MONET
FRENCH LANDSCAPE PAINTING
Sarah Herring,
with Antonio Mazzotta
ISBN 978 1 85709 450 3

EL GRECO TO GOYA
SPANISH PAINTING
Dawson W. Carr
ISBN 978 1 85709 460 2

DUCCIO TO LEONARDO
ITALIAN PAINTING 1250–1500
Simona Di Nepi
ISBN 978 1 85709 421 3

National Gallery publications generate valuable revenue for the Gallery, to ensure that future generations are able to enjoy the paintings as we do today.

Visit www.nationalgallery.org.uk